SMALL WORLD

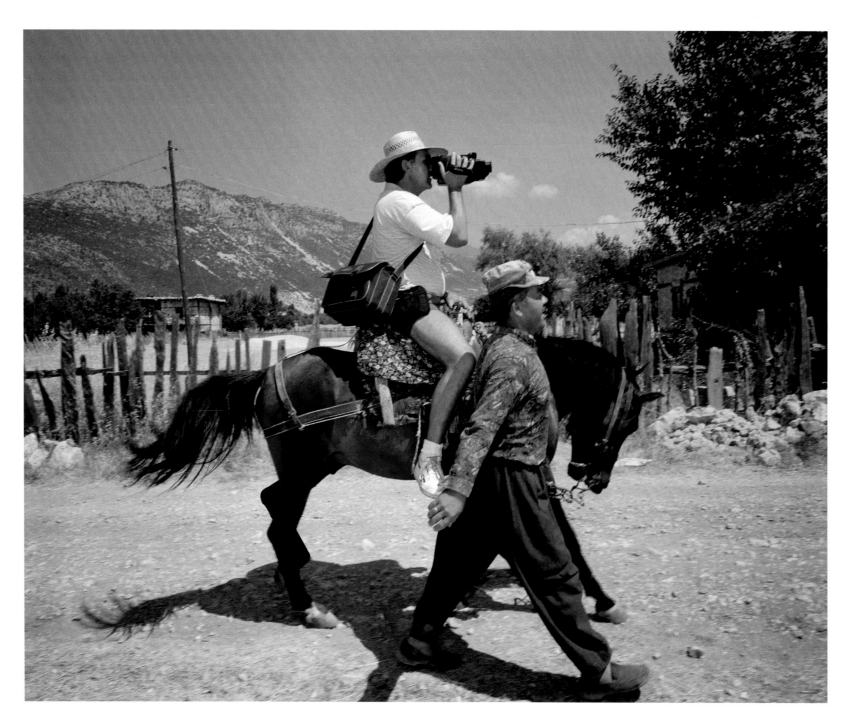

KALKAN, TURKEY

SMALL WORLD
MARTIN PARR

introduced by

GEOFF DYER

DEWI LEWIS PUBLISHING

The tradition of photographing exotic places reaches back almost to the invention of the medium. As the Grand Tour was extended to take in 'the orient' so, in the 1850s, photographers such as Francis Frith lugged their bulky equipment to the eastern Mediterranean and beyond. Once the resulting pictures of the pyramids and other wonders became widely available the desire to go to these places increased. Such was – such *is* – the allure and promise of photographs that people wanted to see the precise spots shown in the pictures. Part of the motive for travelling was, as it were, to *experience* the photographs on site, for real. Of course, there was a lot to see that hadn't been photographed but the places in the frame served as oases or taverns, nodes that visibly determined one's itinerary. Adventurous travellers naturally wanted to get off this pre-beaten track. By so doing, the places they visited gradually became part of the track. Just as Wordsworth complained about the growing numbers of visitors to the Lake District that his poetry had attracted, so travellers to out of the way places began to lament the tourists that came after them.

As travelling has become quicker, easier and cheaper so this problem – or syndrome – has grown more acute. Whereas it once required a considerable effort of will and some ingenuity to get to Egypt, Paul Fussell, in his book *Abroad,* thinks that the coming of efficient, uniform jet travel – which "began in earnest around 1957" – "represents an interesting moment in the history of human passivity." Maybe so but, as Garry Winogrand's airport photographs of the 1960s and 70s attest, it also heralded a great democratic expansion of the opportunity horizon.

The pictures in Martin Parr's *Small World* both sum up this contradictory history and depict what might turn out to be its terminal phase. They show the places photographed by the likes of Frith (the pyramids) and they show how the excitement and promise of Winogrand's pictures has become a source of cramped frustration. When I was seven, in 1965, my parents and I went to London for a week's holiday. One day, as part of this vacation, we took the tube out to Heathrow, not to fly somewhere, just to see the airport. For us it was not a place of departure but a tourist destination in its own right. With the inconvenience of air travel drastically increased in the wake of 9/11 the average traveller – i.e. anyone not in Business or First – dreads going to the airport. To add insult to injury – or, more exactly, guilt to discomfort – we are now acutely conscious of the cost to the environment, of the way that air travel is contributing to global warming. In this context a stay-at-home like Fernando Pessoa seems almost visionary: "What is travel and what use is it? All sunsets are sunsets; there is no need to go and see one in Constantinople."

It's not just the sunsets. When people do travel to Constantinople – or anywhere else for that matter – they can increasingly expect to find many of the things and conveniences taken for granted at home. Back in the 1950s the Swiss tourist Robert Frank travelled through America photographing "the kind of civilization born here and spreading everywhere." Frank was right: forty years down the line Parr finds bits and pieces of the American imperium everywhere. (He also records the contrary tendency whereby one no longer has to travel to Egypt – with the attendant threat of terror – to experience the orient; it can be found in Las Vegas, in the shape of the Luxor.) In order to escape the tentacles of this homogenizing 'civilisation' it is necessary to travel further and further afield. And by so doing you drag those tentacles after you. We are all responsible for the ruination we lament. Wherever you travel some kind of industry develops to cater for you – even if it's not the kind of catering you, personally, were hoping for. A couple of years ago my wife and I travelled to Jaisalmer in the desert of Rajastahn, a place she remembered as being almost Calvino-esque in its isolated beauty. In the decade since her first visit, however, it had been incrementally trashed. With every wall festooned with Indo tat – sarongs, knick-knacks, junk – it resembled nothing else so much as a fortified reincarnation of Camden market. In a cruel twist to the familiar story of how the indigenous people of a place ('Indians' as they were referred to throughout the Americas) traded the wealth of their land for a few worthless trinkets, the people of Jaisalmer, having put their heritage in hock, were left *selling* worthless trinkets that no one wanted – and, as a result, we, the *tourists*, felt cheated by the commerce that had sprung up to pander to us.

The effects of tourism are, of course, not uniform. Not all places have given themselves over entirely to tourism. But, as Mary McCarthy wrote almost half a century ago, "there is no use pretending that the tourist Venice is not the real Venice, which is possible with other cities – Rome or Florence or Naples. The tourist Venice *is* Venice… Venice is a folding picture-postcard of itself."

Venice is an extreme case. Even in Rome or Florence, however, visitors feel reassured by the way there are so many others doing, seeing – and photographing – the same things. Off-putting to some, a restaurant offering a 'Tourist Menu' is tempting to many. At the risk of being racist, the Japanese – the "lens-faced Japanese", in Martin Amis's phrase – seem to take particular comfort in being photographed in places where everyone else is being photographed. People go to places not to see the places but to obtain evidence – photographs of themselves – of having been there. (Actually, this argument has been rehearsed so many times that it's a negative version of the

same tendency. By making the point I am effectively making a record of myself standing in front of a cultural edifice signifying superior worth and discernment.)

Parr takes things a logical stage further: photographing people being photographed and taking photographs. In this respect the *Small World* pictures stand comparison with the large-scale images by Thomas Struth in which we look at visitors looking at famous works of art (which, lest we forget, are also tourist attractions). The difference is that whereas in Struth's photographs the greatness – or aura or whatever you want to call it – of these art works survives the process of mediation, in Parr's photographs 'place' and visitor work to their mutual diminution. Tacitly – or maybe not even tacitly – he endorses the verdict of the narrator in Don DeLillo's *The Names*:

"Tourism is the march of stupidity. You're expected to be stupid. The entire mechanism of the host country is geared to travellers acting stupidly. You walk around dazed, squinting into fold-out maps. You don't know how to talk to people, how to get anywhere, what the money means, what time it is, what to eat or how to eat it. Being stupid is the pattern, the level and the norm."

Like DeLillo, Parr is not scathing or moralistic about this perceived failing. He enjoys it too much for that. There's too much mileage in it.

It is as hard for photographers to be funny as it is for a critic to explain a joke (this probably has something to do with the medium's defining quality of reproducibility; how many jokes can withstand infinite repetition?) but they *can* be witty. The wittiest photographer was Henri Cartier-Bresson (with Winogrand a close second) who, if he had worked in colour, might have relied on some of the same devices as Parr. Ironically, it was at the opening of *Small World* in 1995 at Centre Nationale de la Photographie, Paris, that Cartier-Bresson told Parr that he must be "from a different planet." One sees what he means but one also sees that, at some point in their orbits, their two planets are thrown into unexpected alignment. In the random accidents of colour Parr contrives to find a version of the rhymes and puns that Cartier-Bresson discovered in the fleeting symmetries of pictorial geometry.

Are Parr's visual jokes at the expense of the people depicted? Is he fair? In the context of a world in which war photographers are snatching images of death, maiming, grief and suffering, Parr's trespasses are easily forgiven. (Having mentioned war it's worth remembering that, since Parr works in some of the most intensively

photographed spots on earth, he can probably claim immunity on the grounds that they are, to use a phrase from Vietnam, free-fire zones.) I suspect, also, that the people in the photographs would recognise themselves and their fellow-travellers. They would agree that, although they have chosen and paid to come to these places, sight-seeing in particular and holidaying generally are often the opposite of fun – partly because of all the other *tourists*. (Like car drivers moaning about traffic, the discerning tourist often complains that a place is 'too touristy'.) And the money, even in supposedly cheap places, slips through your fingers like water. Forty years on, my father is still traumatised by the extraordinary price of the choc-ice we almost bought outside Madame Tussaud's during that trip to London. In this respect he has something in common with D. H. Lawrence who, in *Sea and Sardinia*, is in a state of constant fury about being overcharged: "I am thoroughly sick to death of the sound of liras... Liras – liras – liras – nothing else. Romantic, poetic, cypress-and-orange-tree Italy is gone. Remains an Italy smothered in the filthy smother of innumerable lira notes: ragged, unsavoury paper money so thick upon the air that one breathes it like some greasy fog."

There is no way round it: to travel, either as backpacker or package tourist, is to be forced into being an incessant consumer. Factor in queues, hassle, jetlag and tummy upsets and it's a wonder, even now, when travel has become so *easy*, that people still want to do it. Philip Larkin certainly didn't want to, but he did consent, every year, to take his mother away for a dismal week somewhere in England (he didn't believe in 'abroad'). The experience led him to develop "a theory that 'holidays' evolved from the medieval pilgrimage, and are essentially a kind of penance for being so happy and comfortable in one's daily life."

That's what the pictures in *Small World* depict: the form and state of modern, faithless pilgrimage. I think, next year, I might try Mecca.

GEOFF DYER

LEANING TOWER, PISA, ITALY

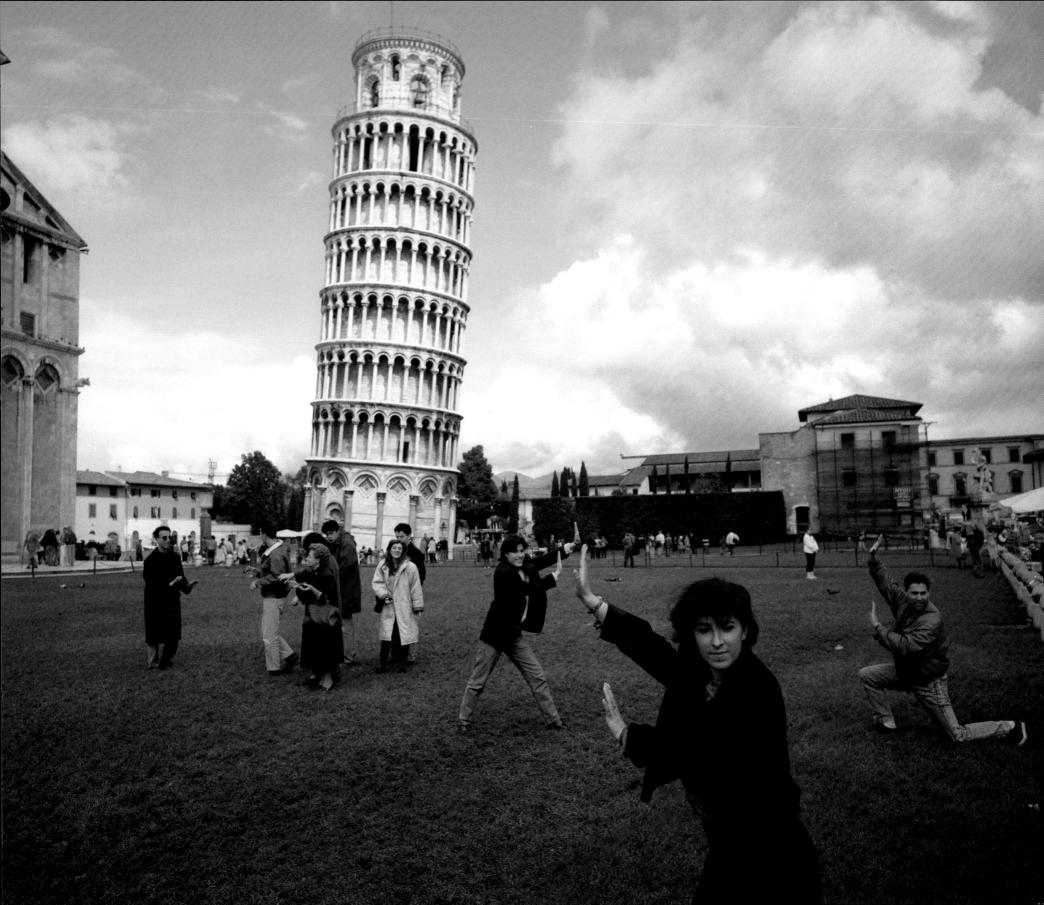

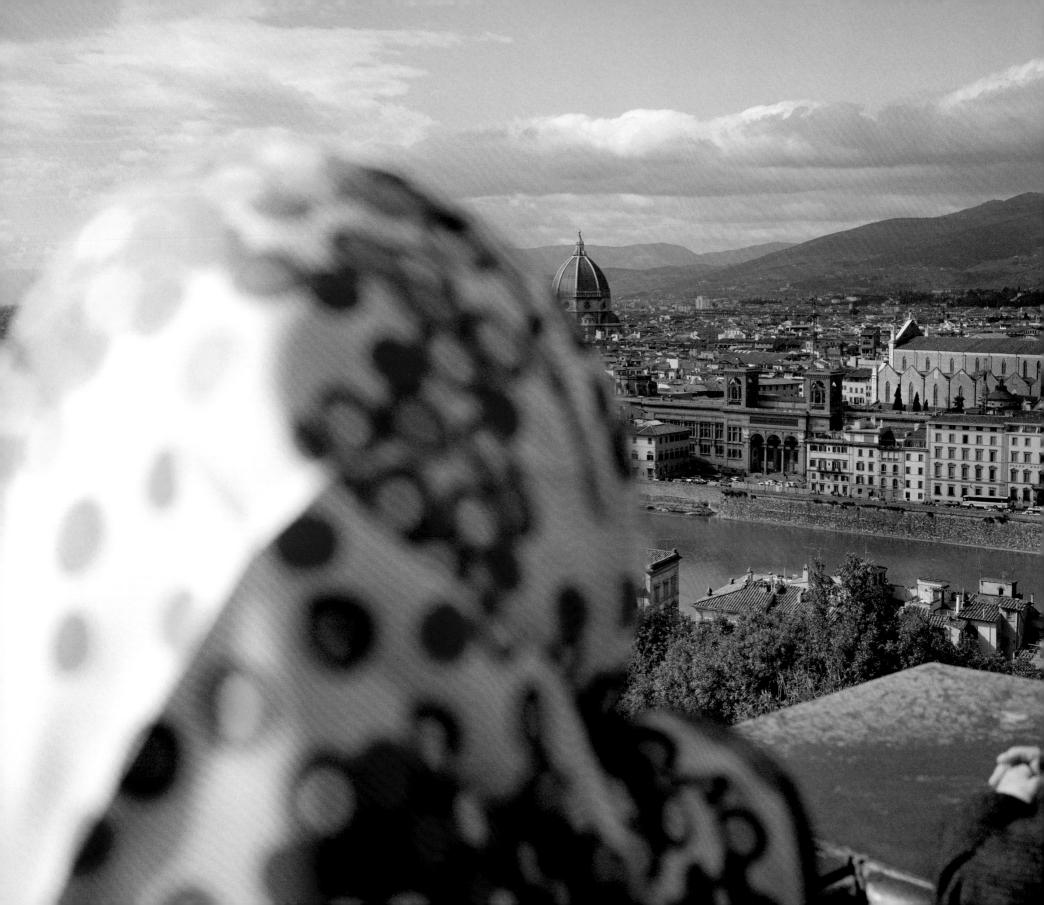

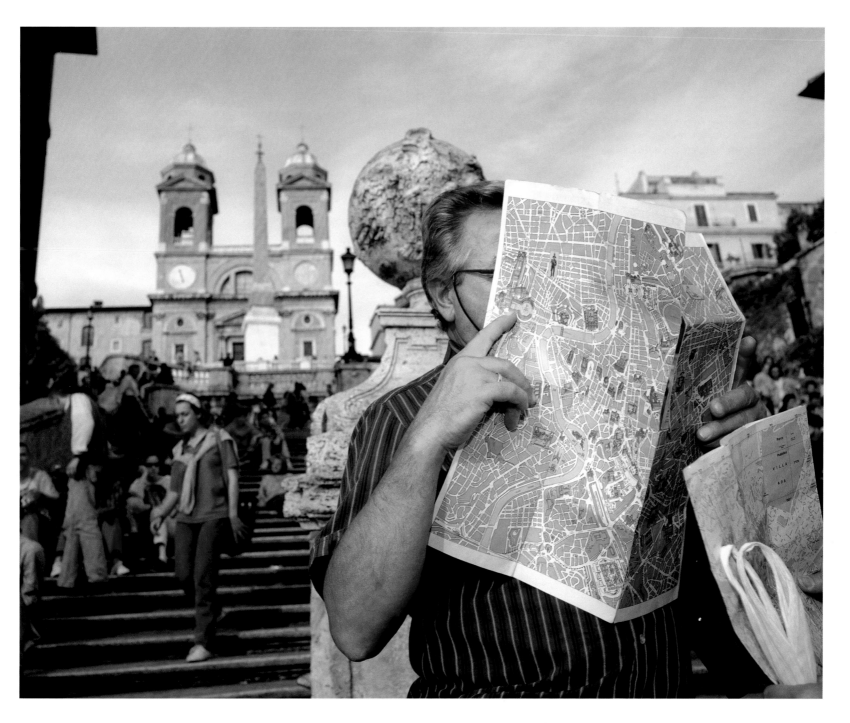

above: SPANISH STEPS, ROME, ITALY
left: FLORENCE, ITALY

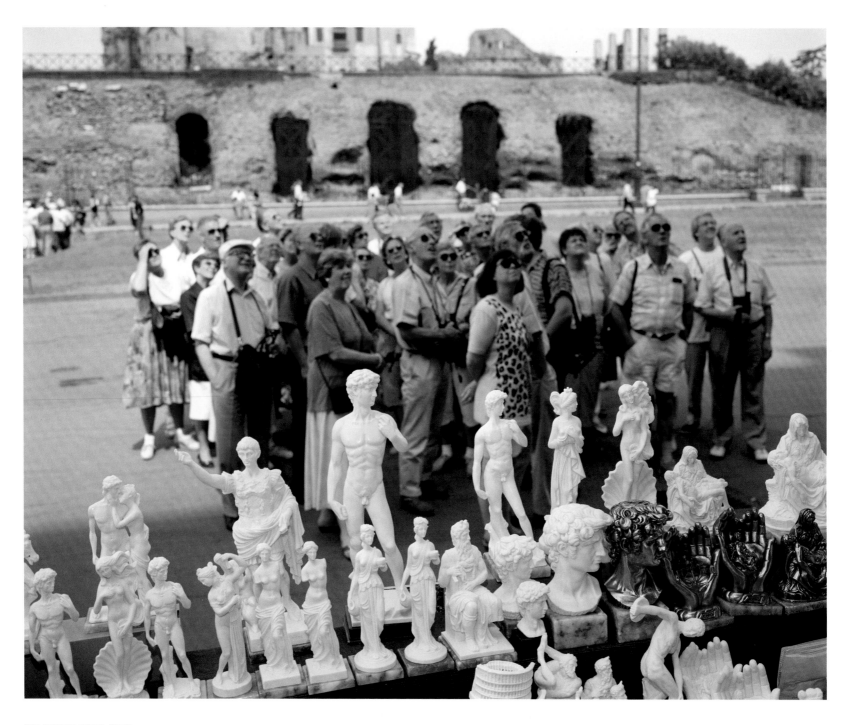

COLOSSEUM, ROME, ITALY

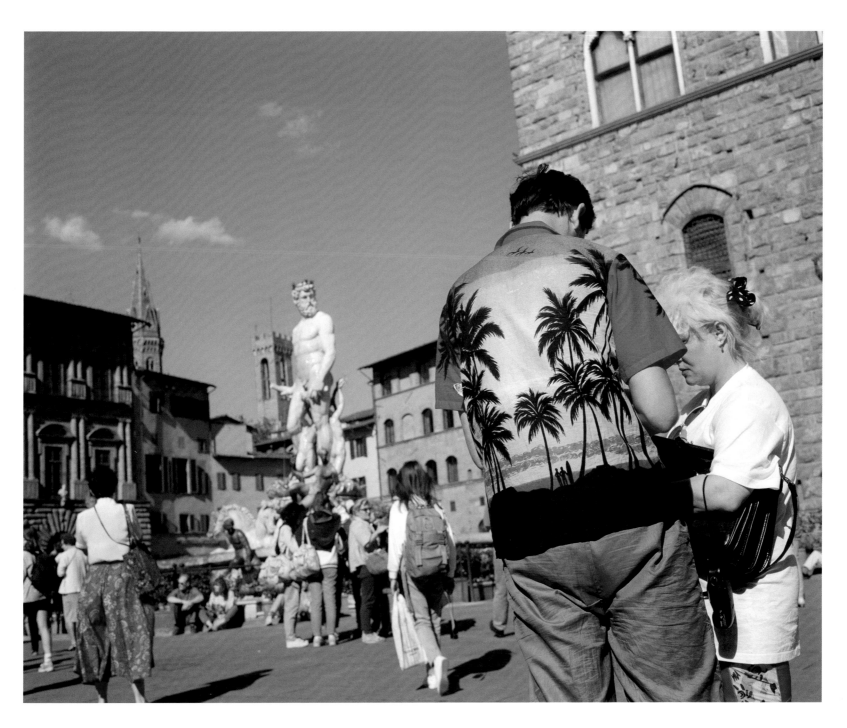

PIAZZA SIGNORIA, FLORENCE, ITALY

THE VENETIAN HOTEL, LAS VEGAS, USA

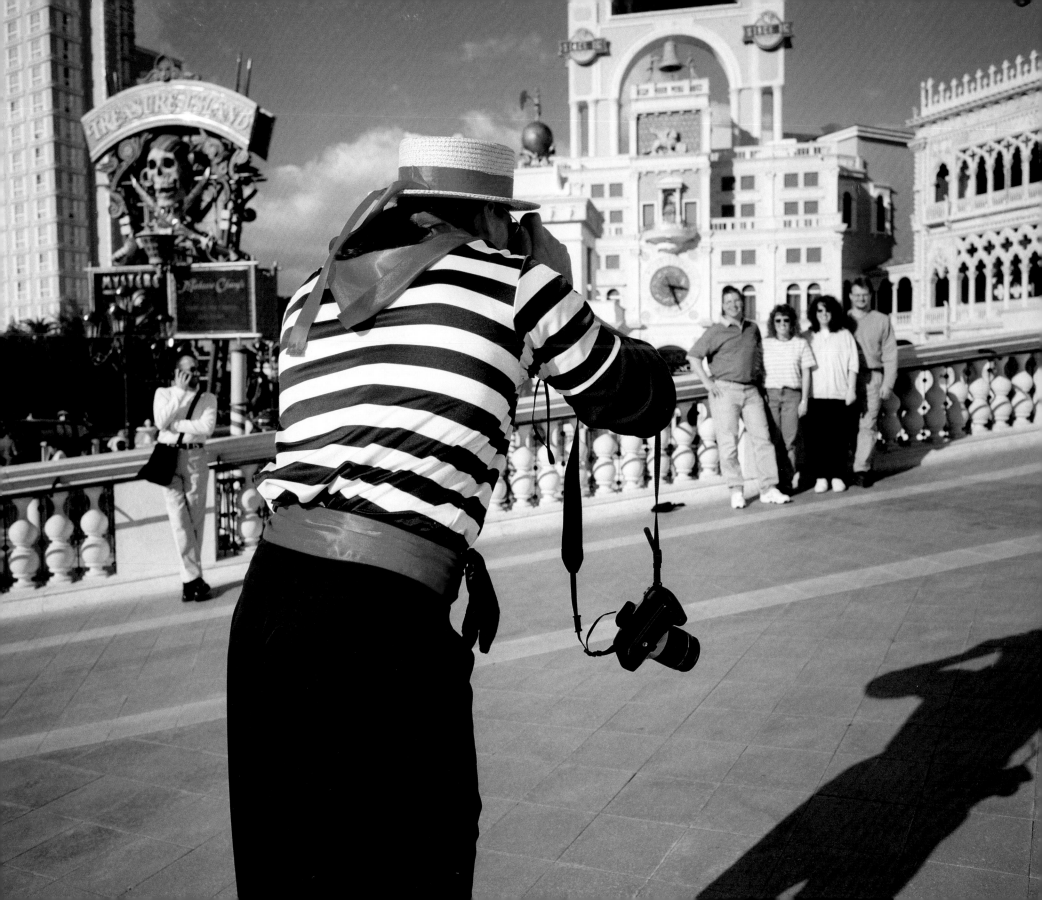

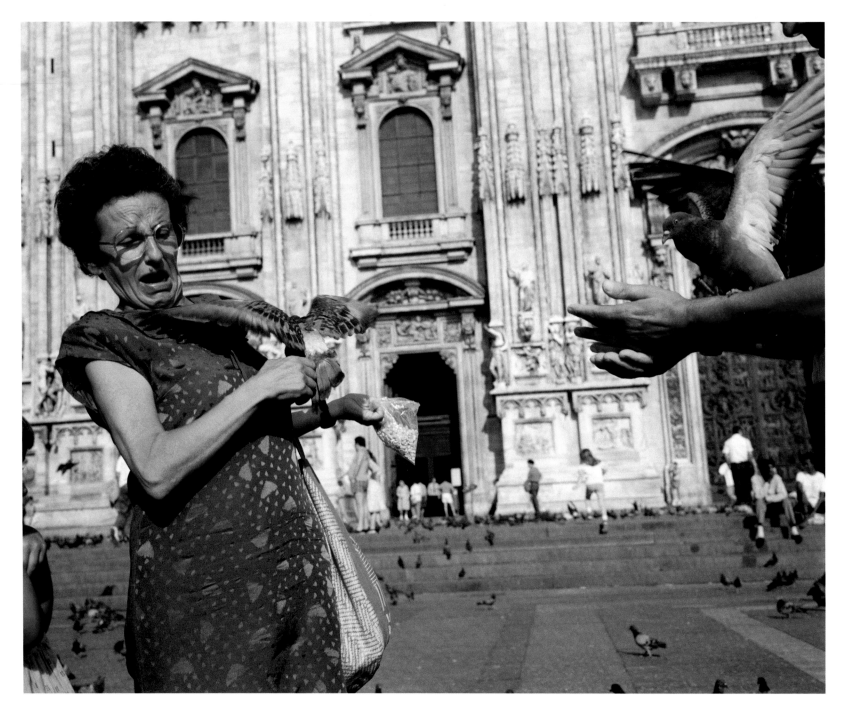

DUOMO, MILAN, ITALY

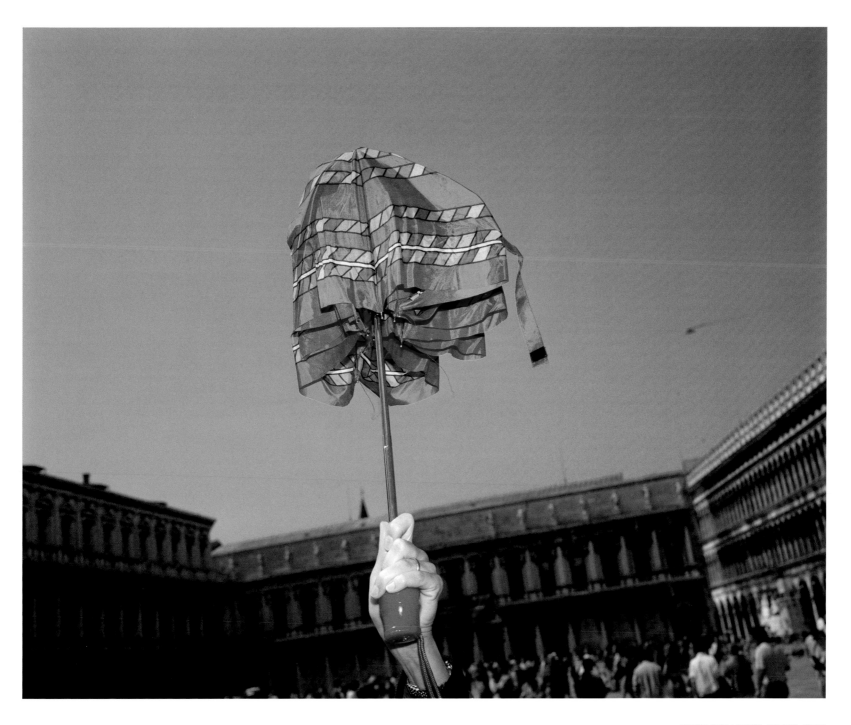

PIAZZA SAN MARCO, VENICE, ITALY

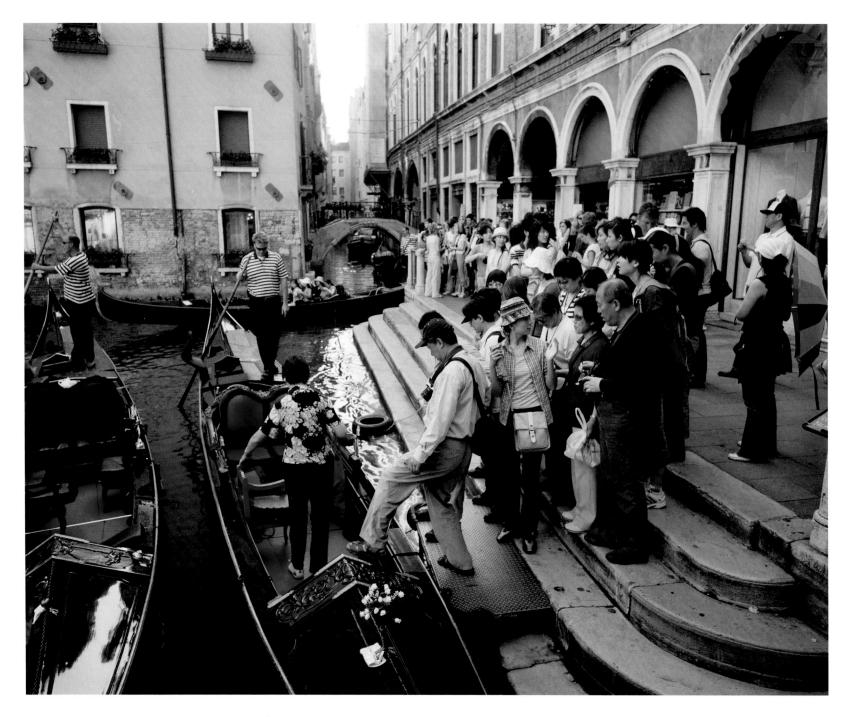

VENICE, ITALY

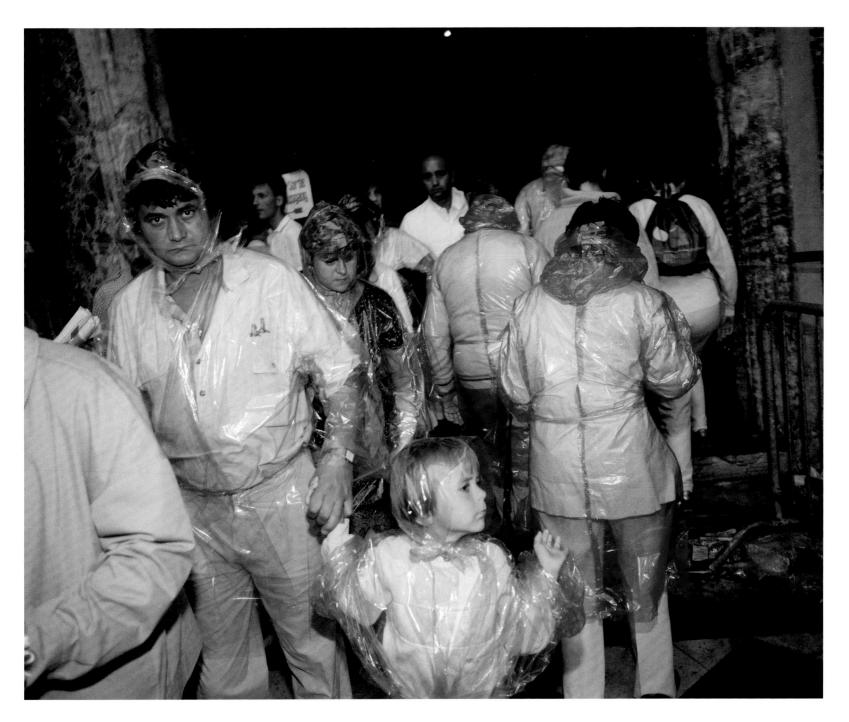

BASILICA SAN MARCO, VENICE, ITALY

POLYNESIAN CULTURAL CENTRE, OAHU, HAWAII

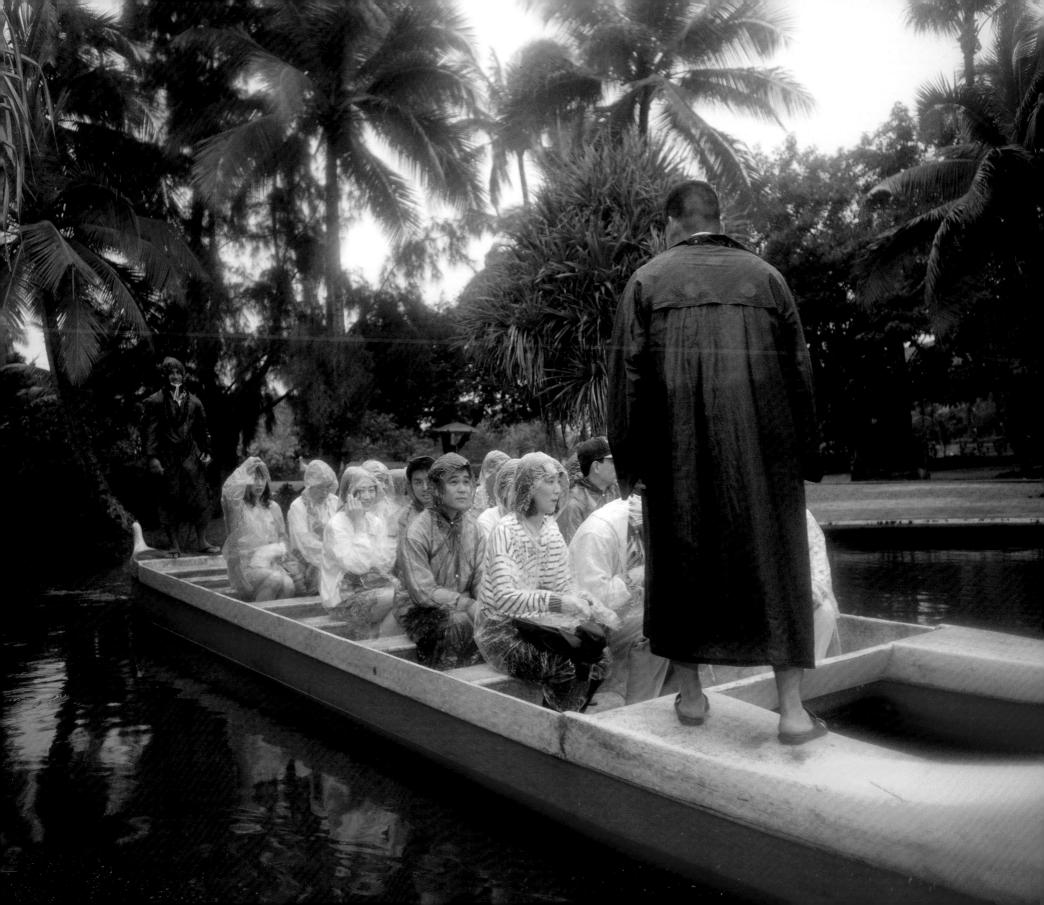

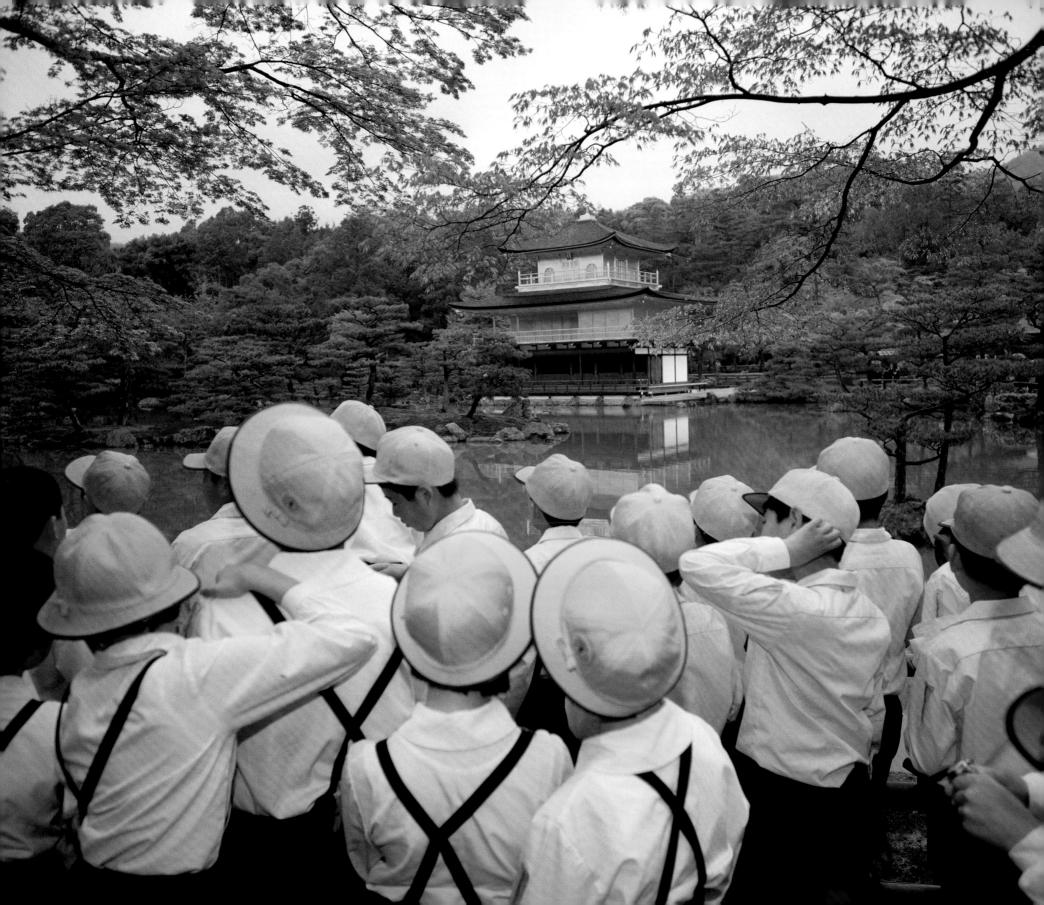

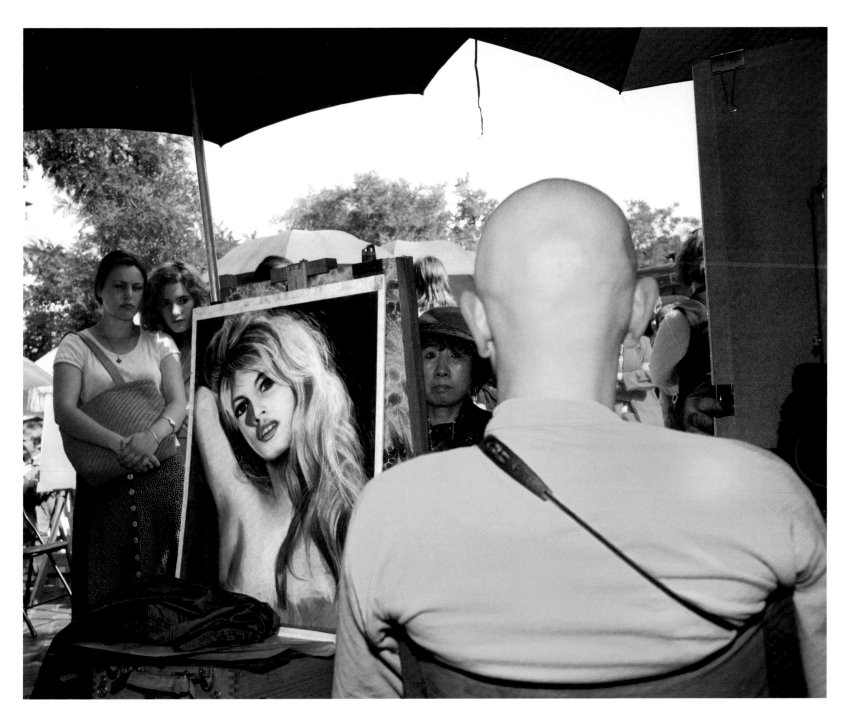

above: PARIS, FRANCE
left: GOLDEN TEMPLE, KYOTO, JAPAN

SAGRADA FAMILIA, BARCELONA, SPAIN

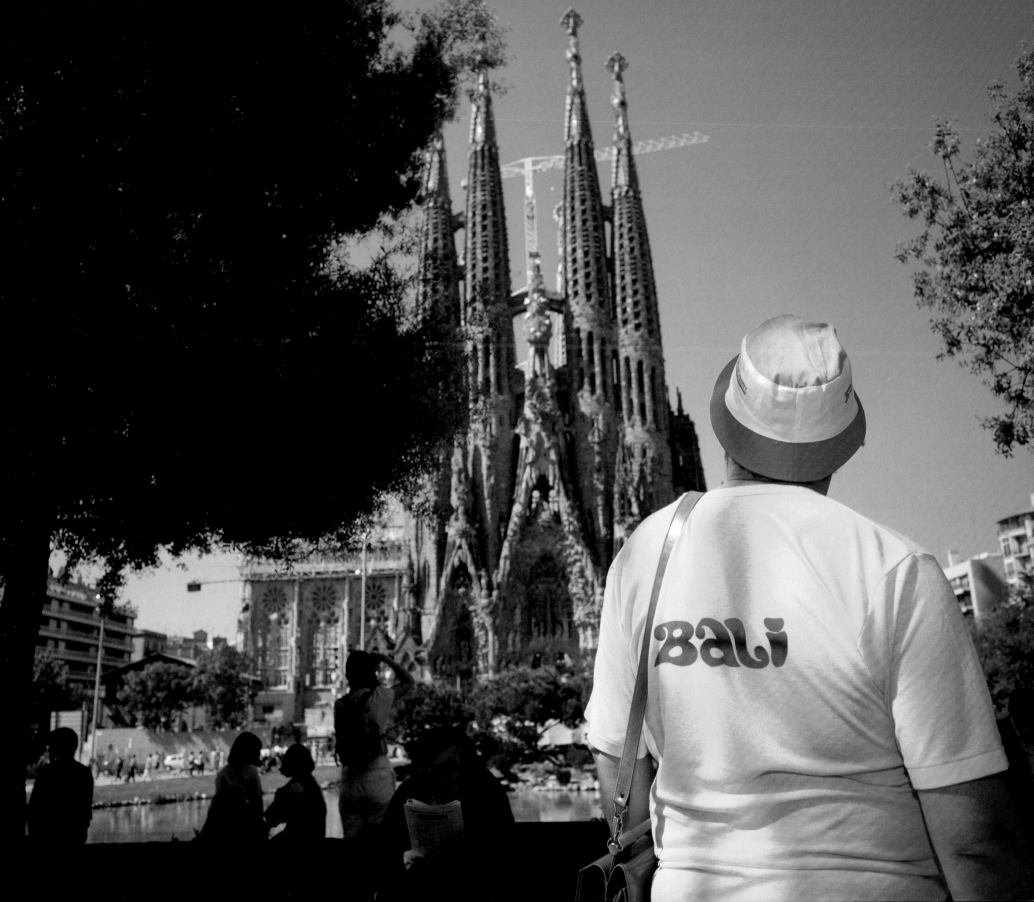

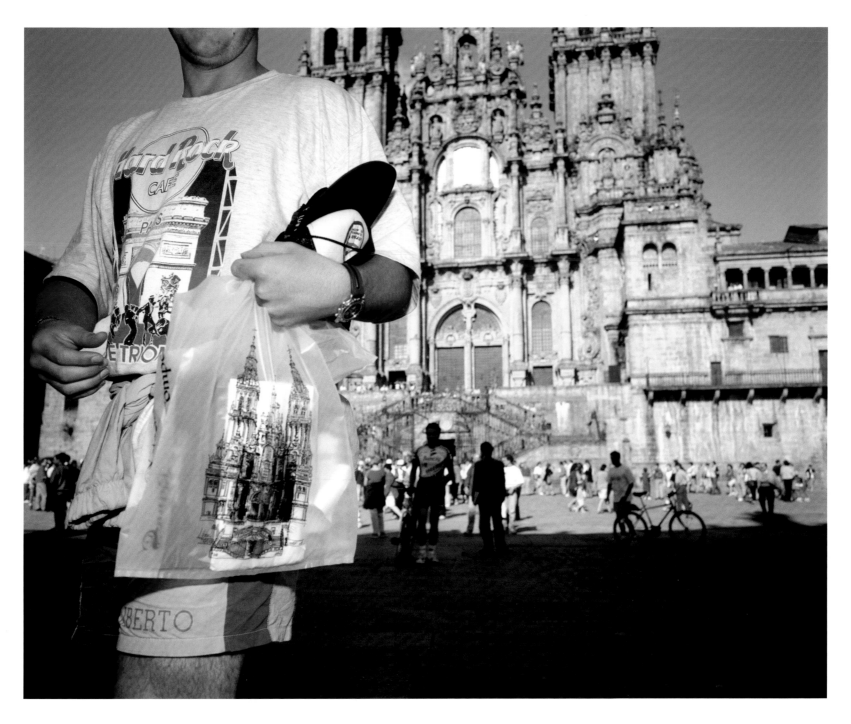

above: SANTIAGO DE COMPOSTELA, SPAIN
left: NOTRE DAME, PARIS, FRANCE

27

EIFFEL TOWER, PARIS, FRANCE

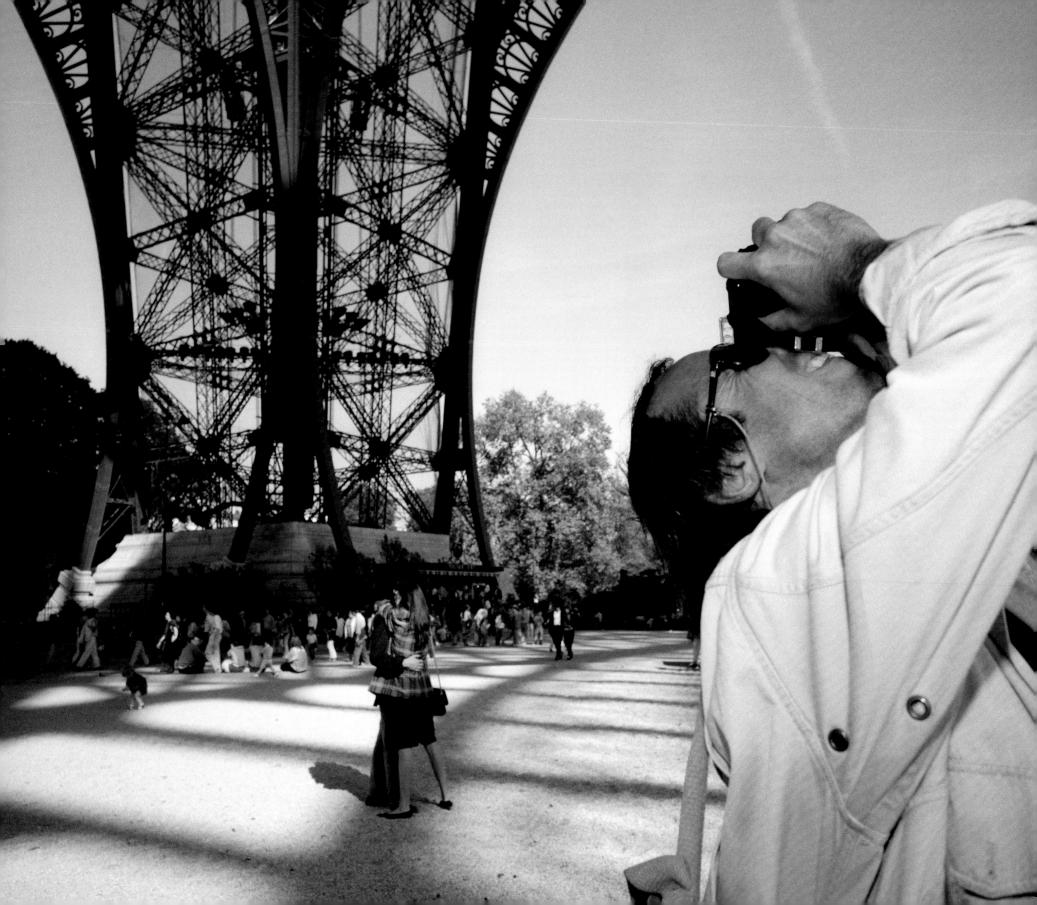

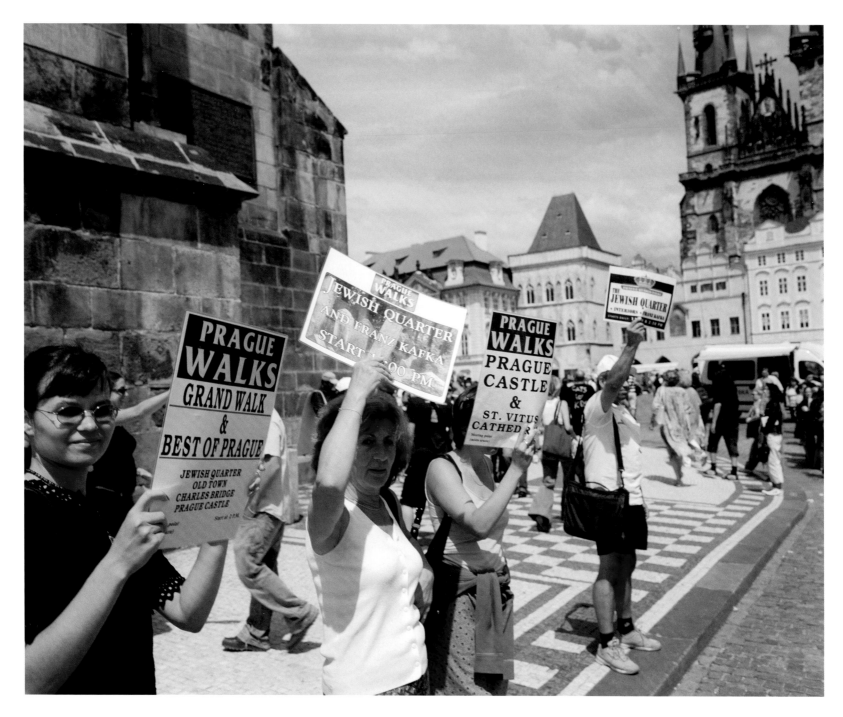

PRAGUE, CZECH REPUBLIC

30

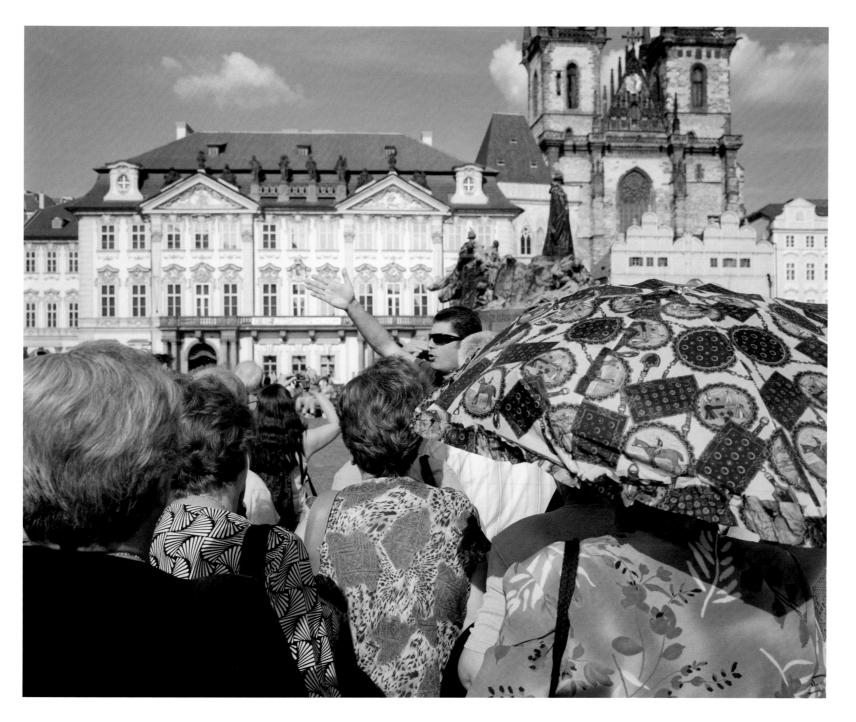

PRAGUE, CZECH REPUBLIC

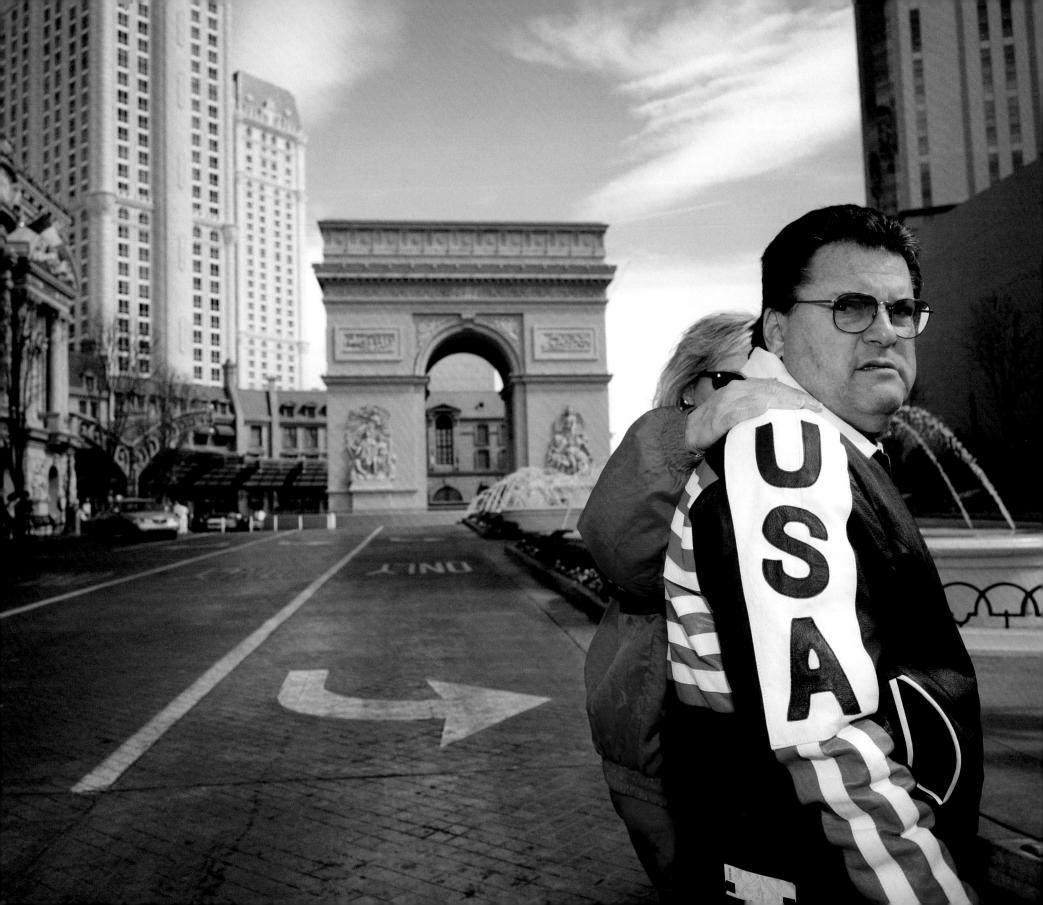

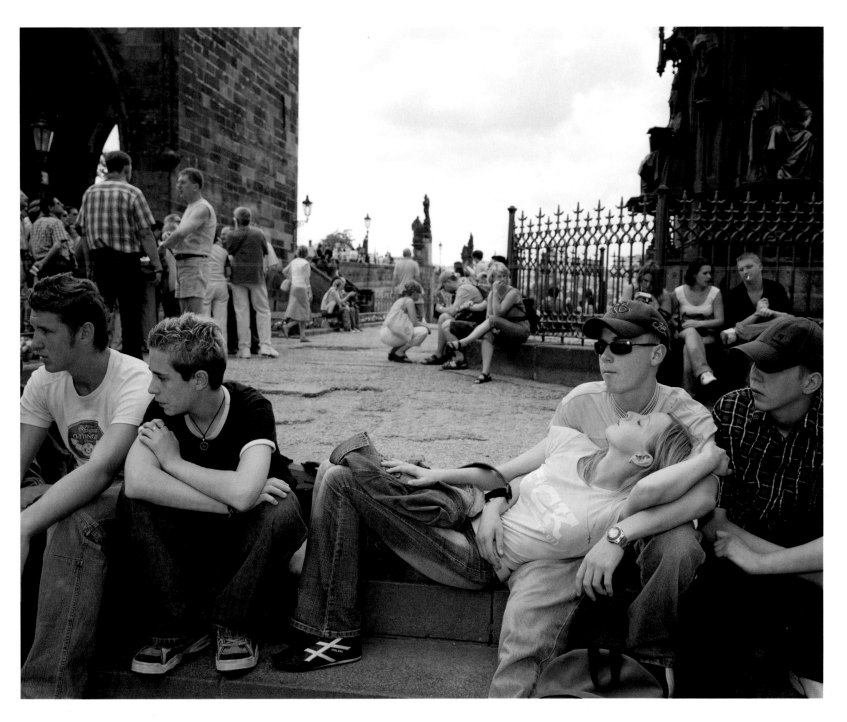

above: PRAGUE, CZECH REPUBLIC
left: LAS VEGAS, USA

33

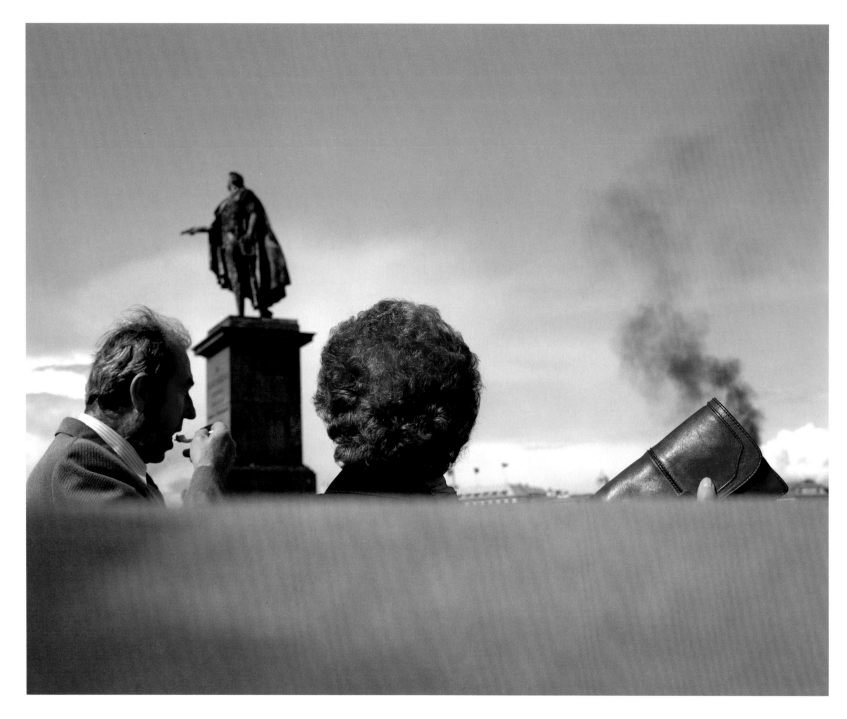

STOCKHOLM, SWEDEN

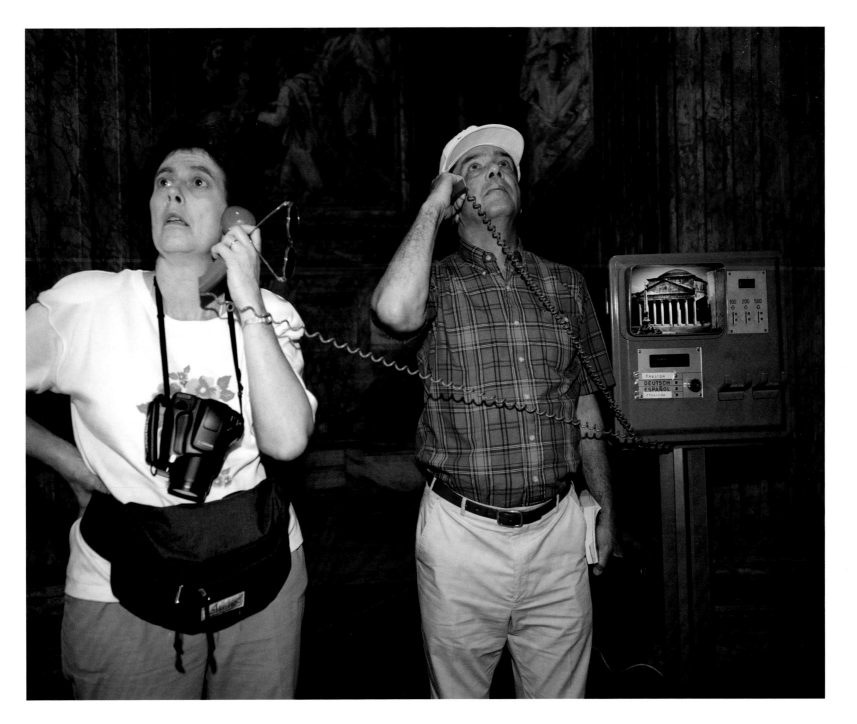

PANTHEON, ROME, ITALY

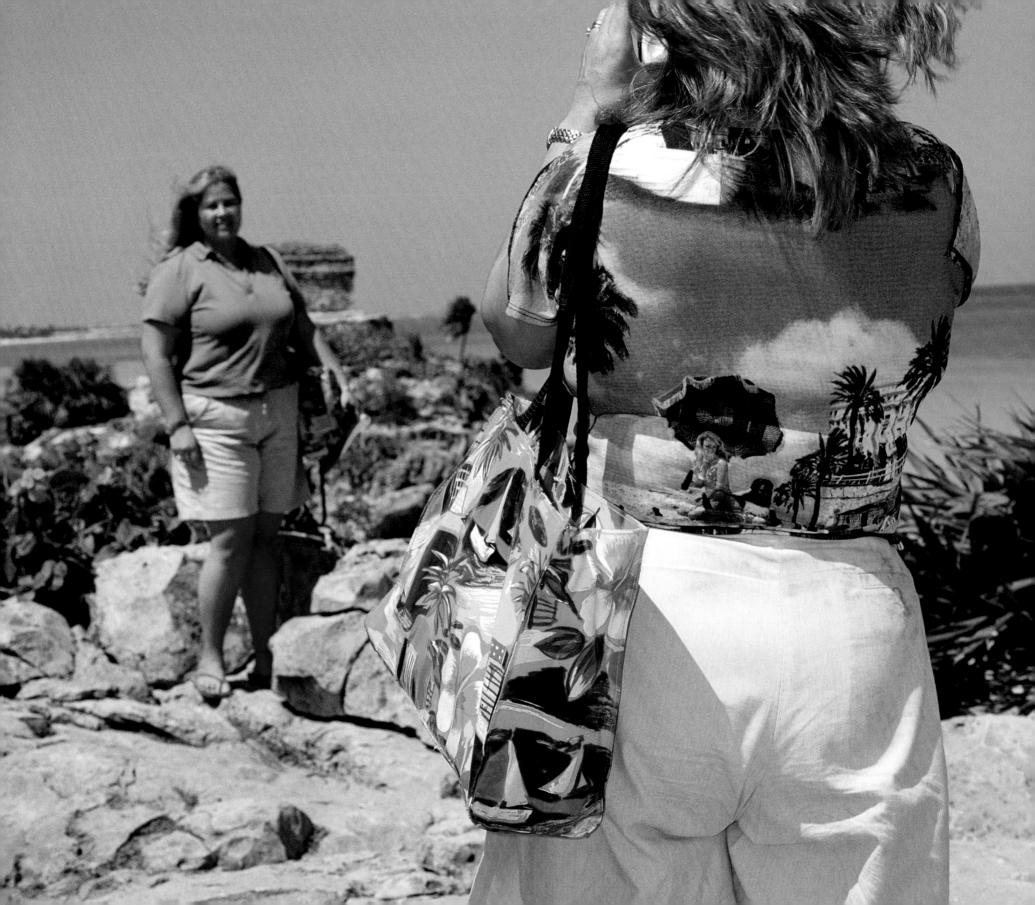

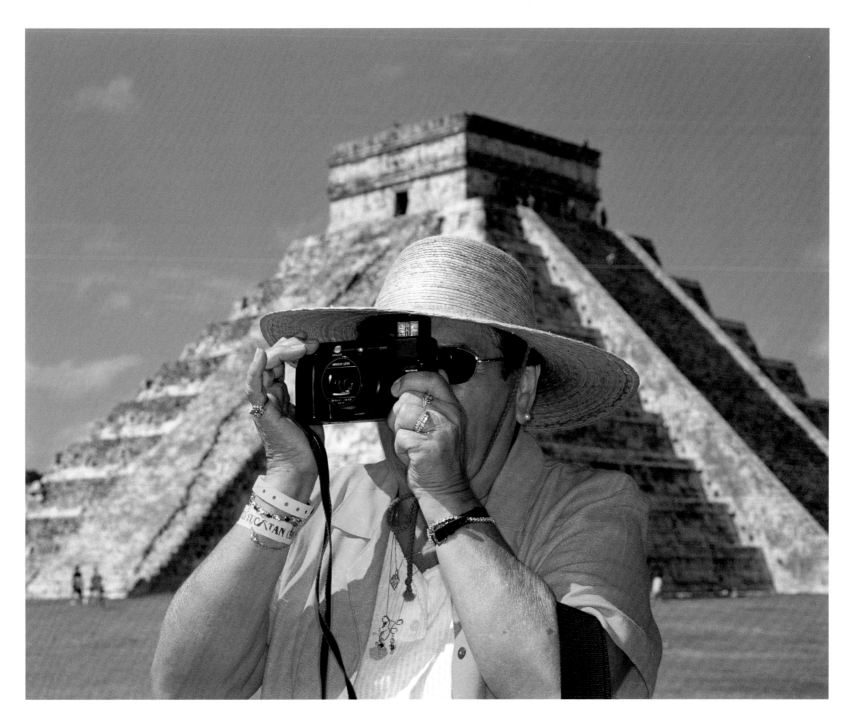

above: MEXICO
left: TULUM, MEXICO

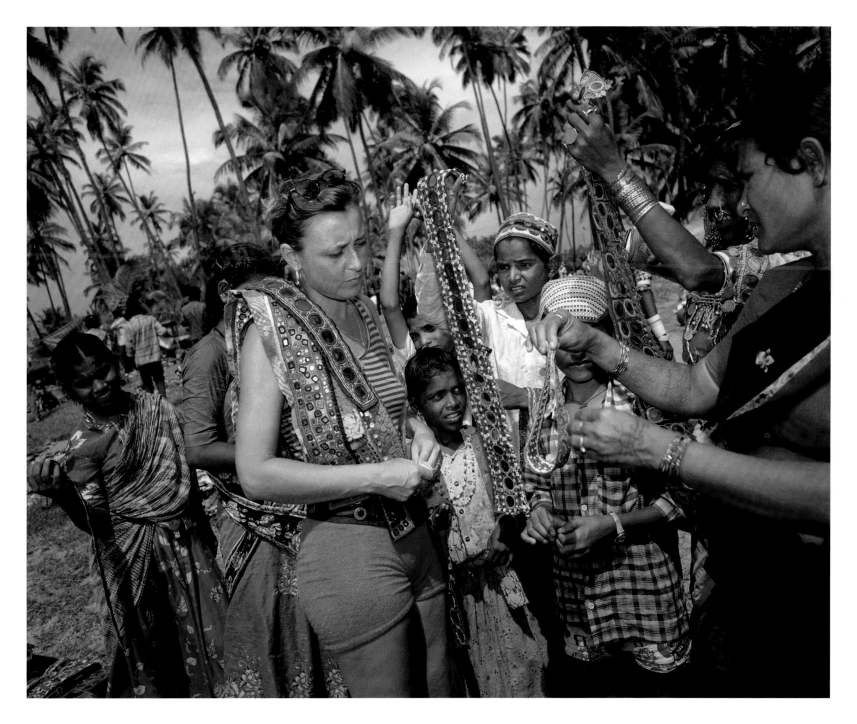

GOA, INDIA

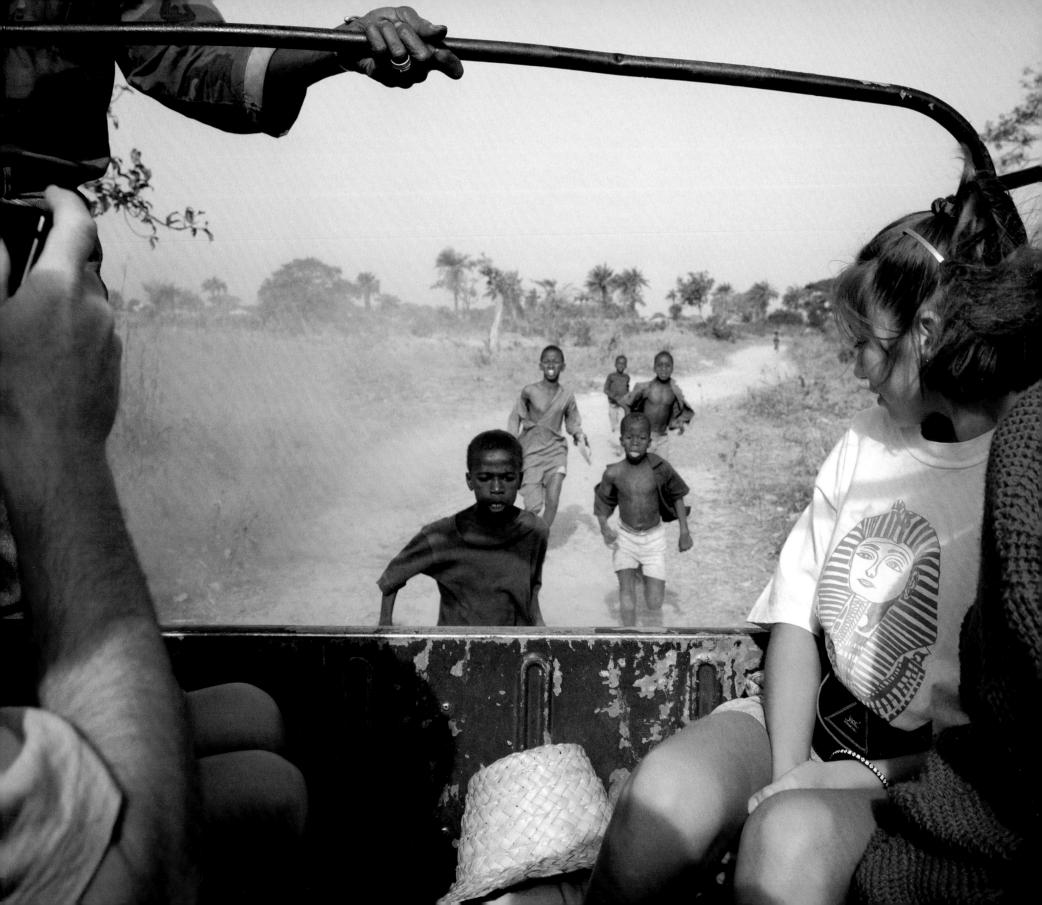

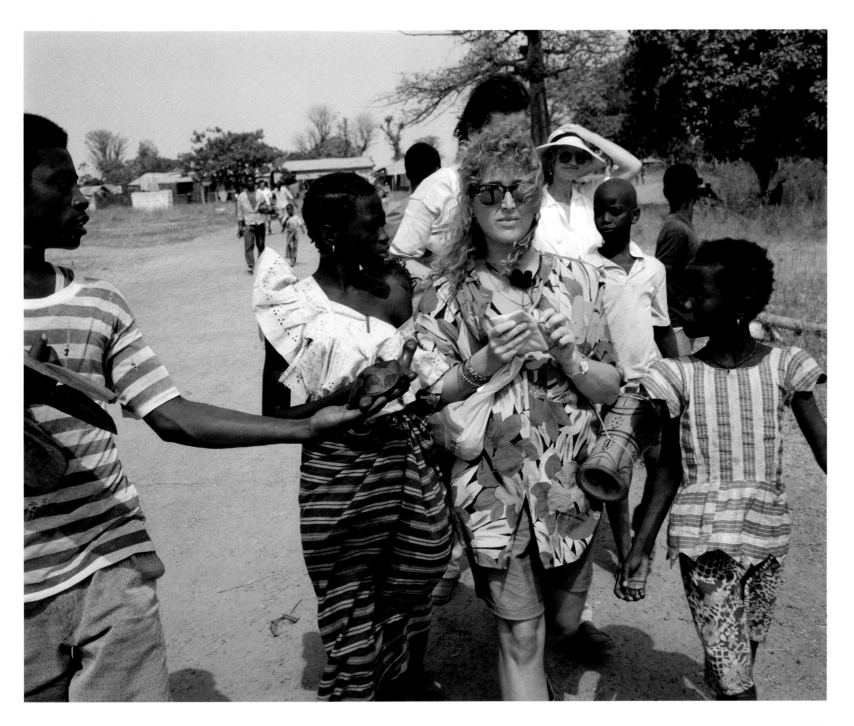

above: JUFFURE, THE GAMBIA, AFRICA
left: THE GAMBIA, AFRICA

41

COPACABANA BEACH, RIO DE JANEIRO, BRAZIL

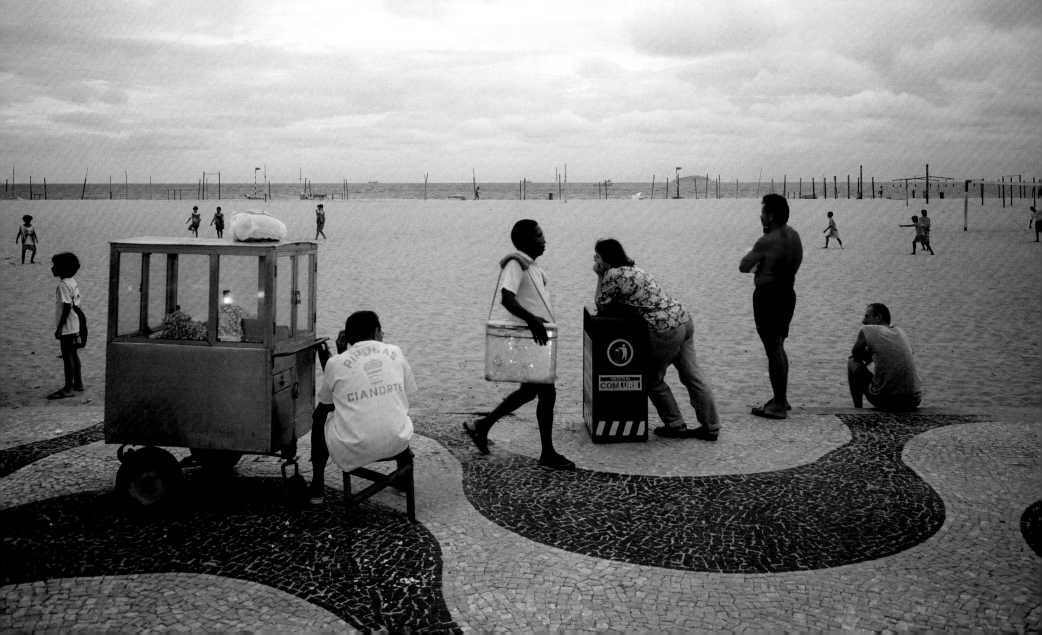

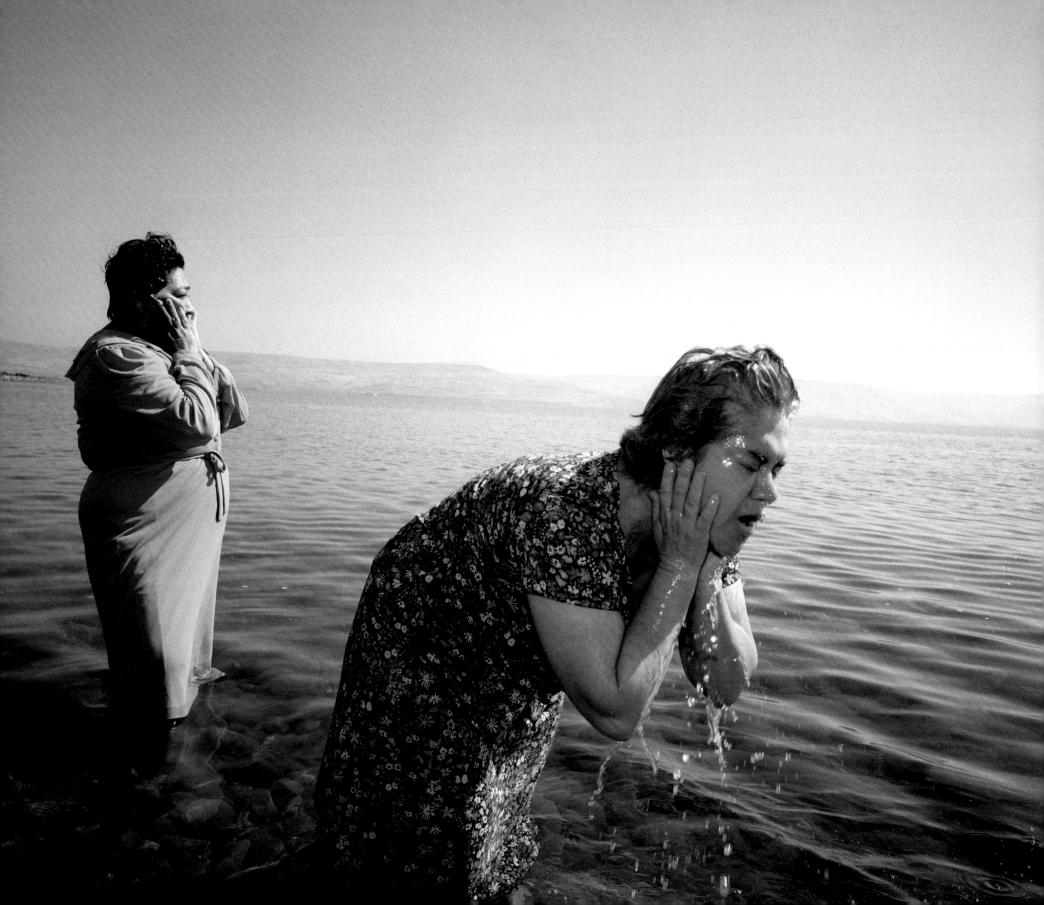

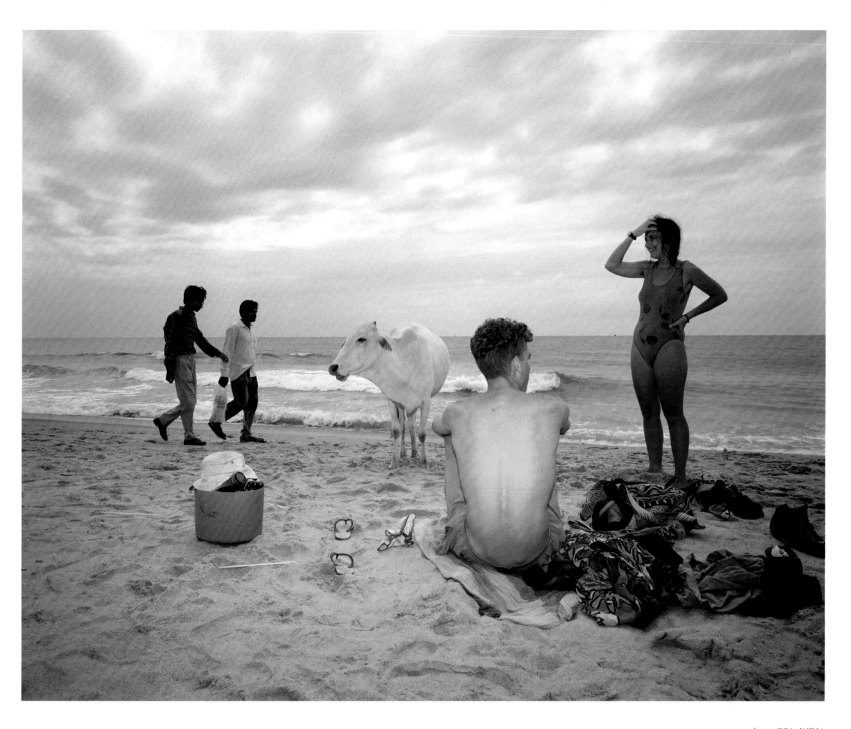

above: GOA, INDIA
left: SEA OF GALILEE, ISRAEL

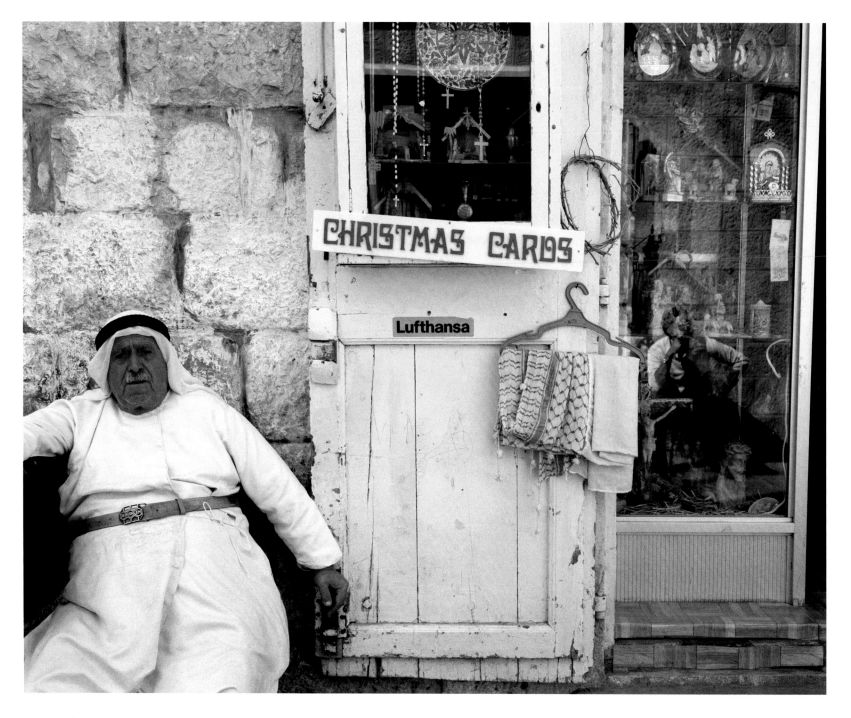

BETHLEHEM, ISRAEL

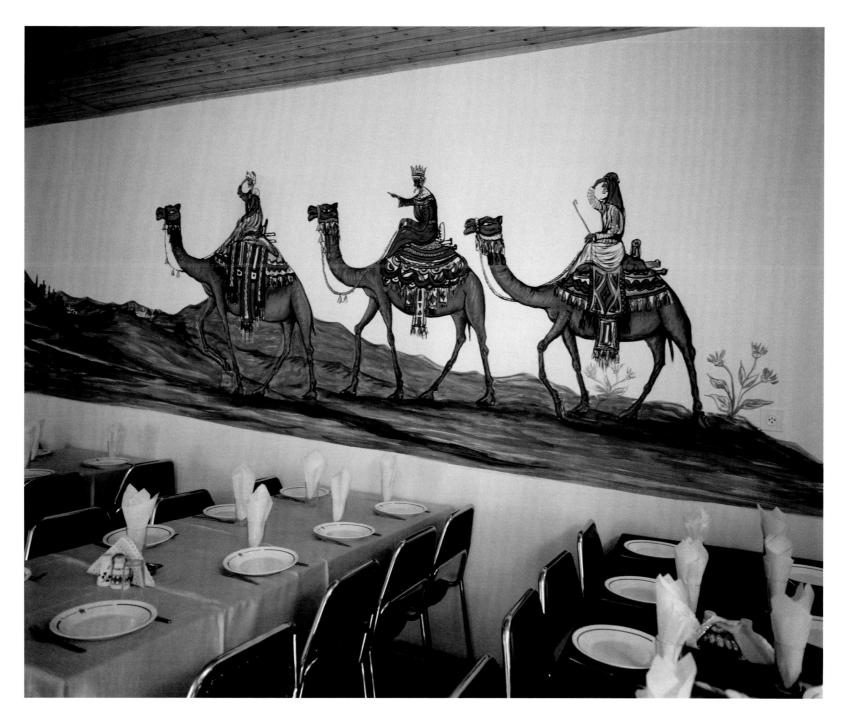

BETHLEHEM, ISRAEL

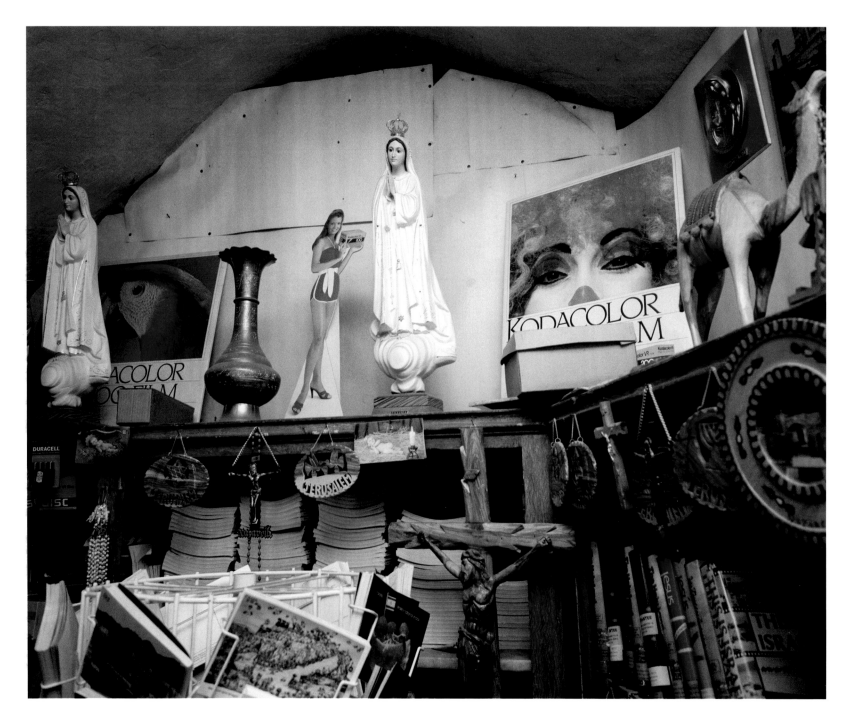

NAZARETH, ISRAEL

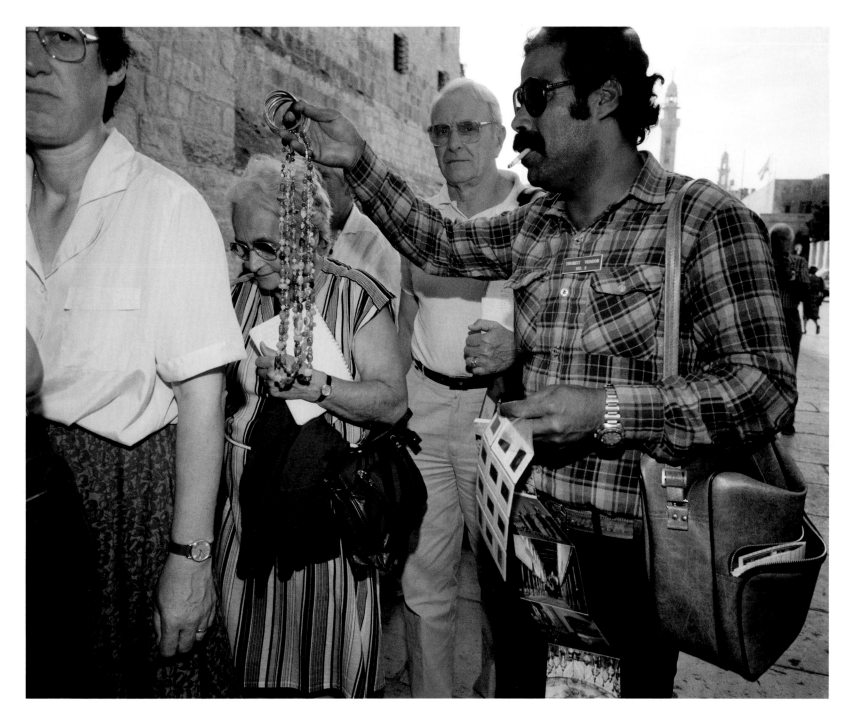

BETHLEHEM, ISRAEL

THE SPHINX, GIZA, EGYPT

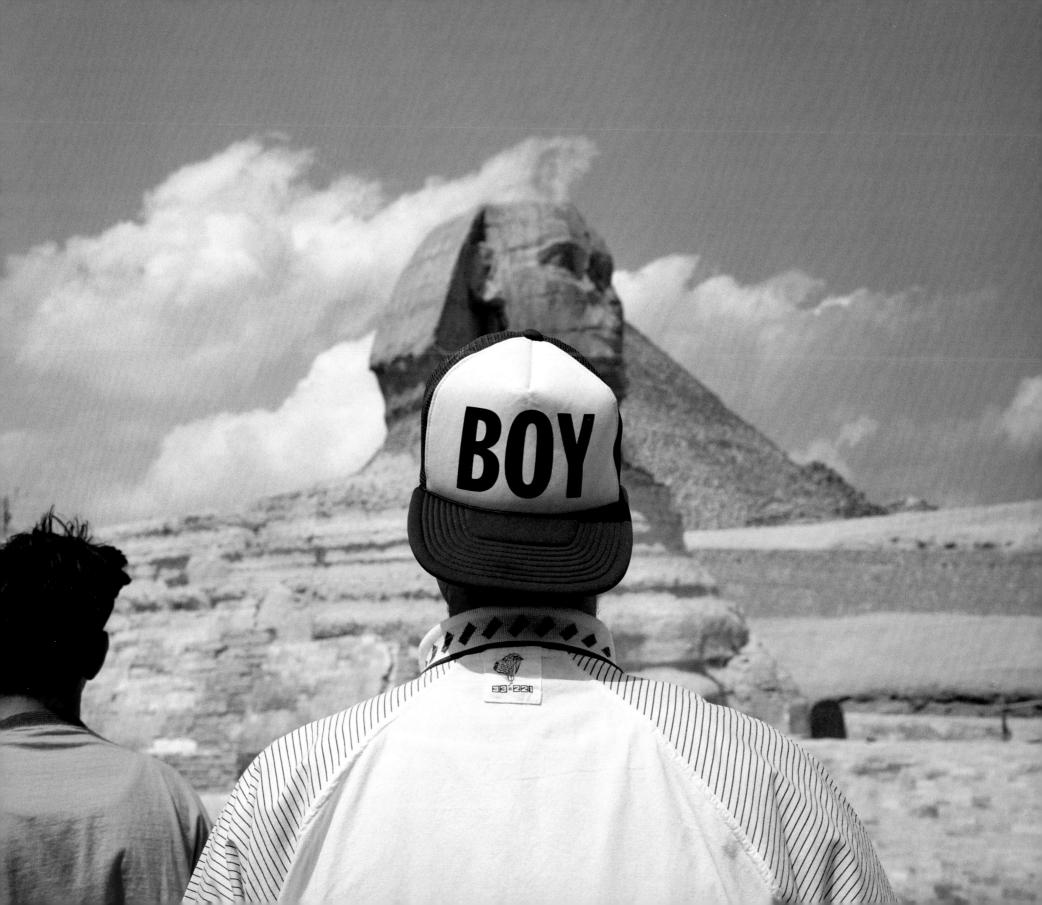

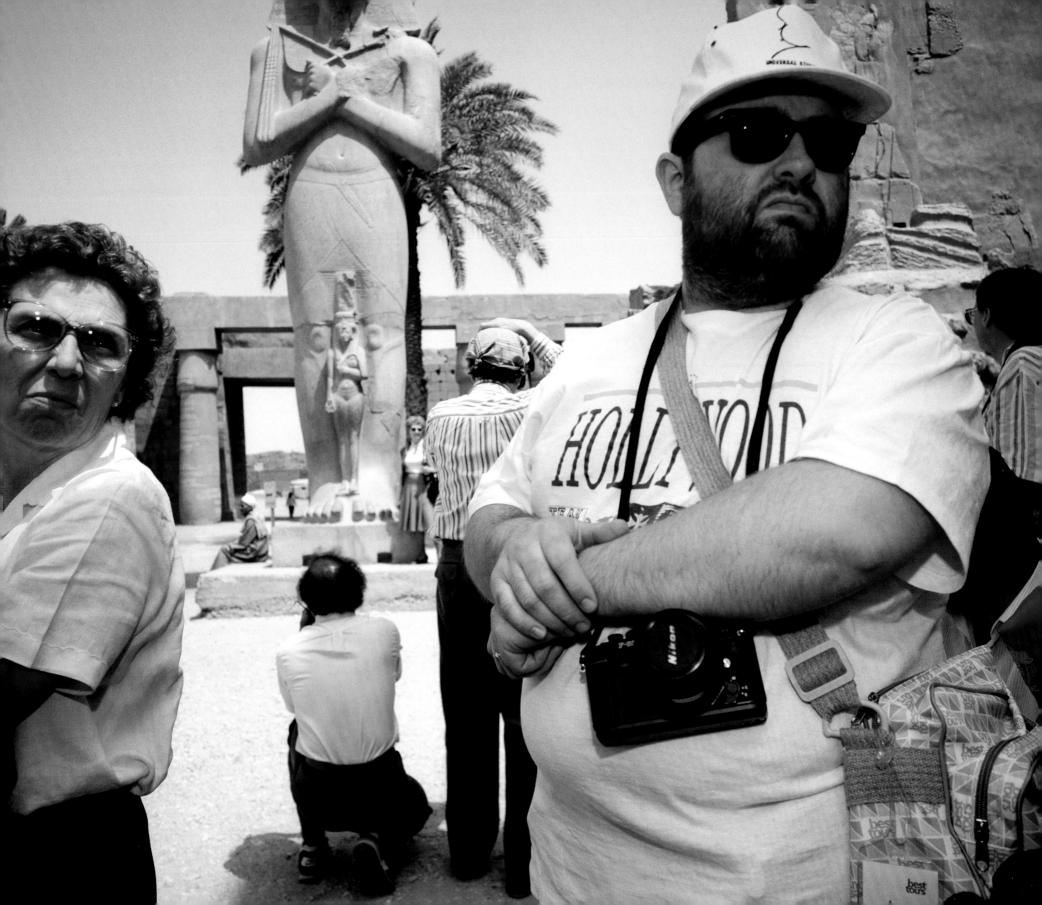

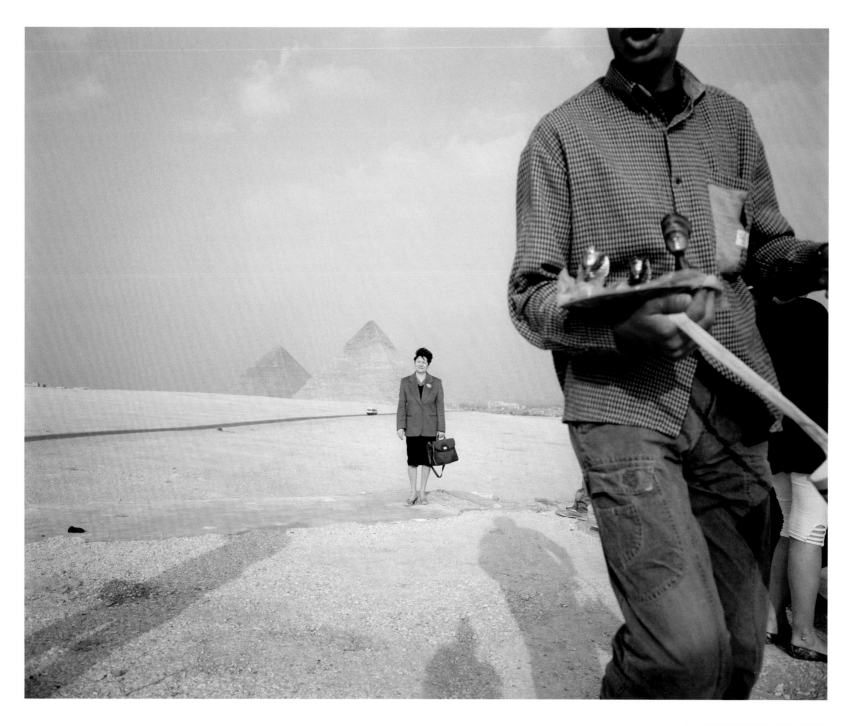

above: THE PYRAMIDS, GIZA, EGYPT
left: KARNAK TEMPLE, LUXOR, EGYPT

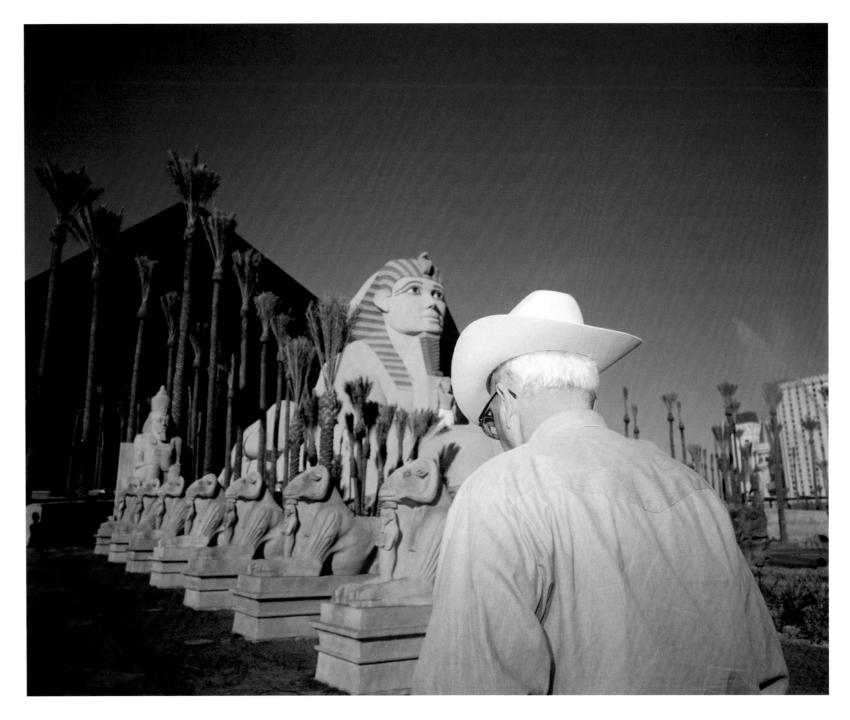

above: LUXOR HOTEL AND CASINO, LAS VEGAS, USA
right: THE PYRAMIDS, GIZA, EGYPT

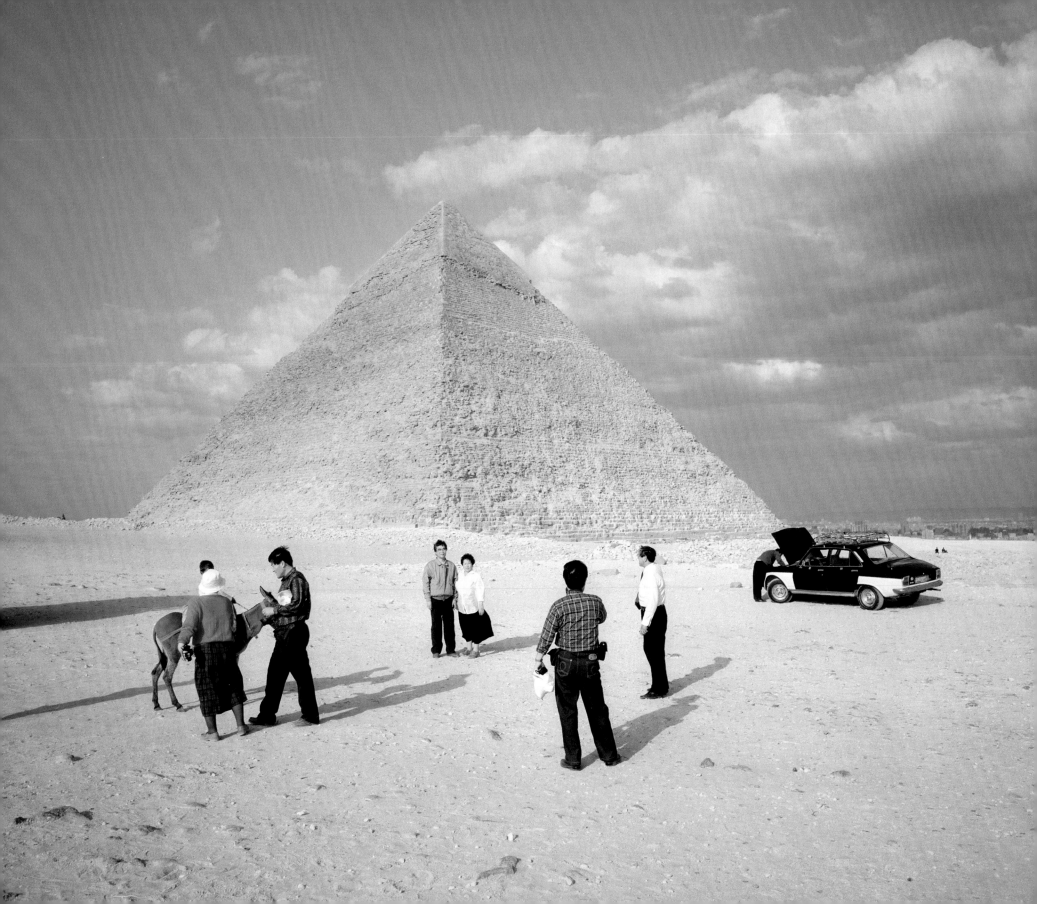

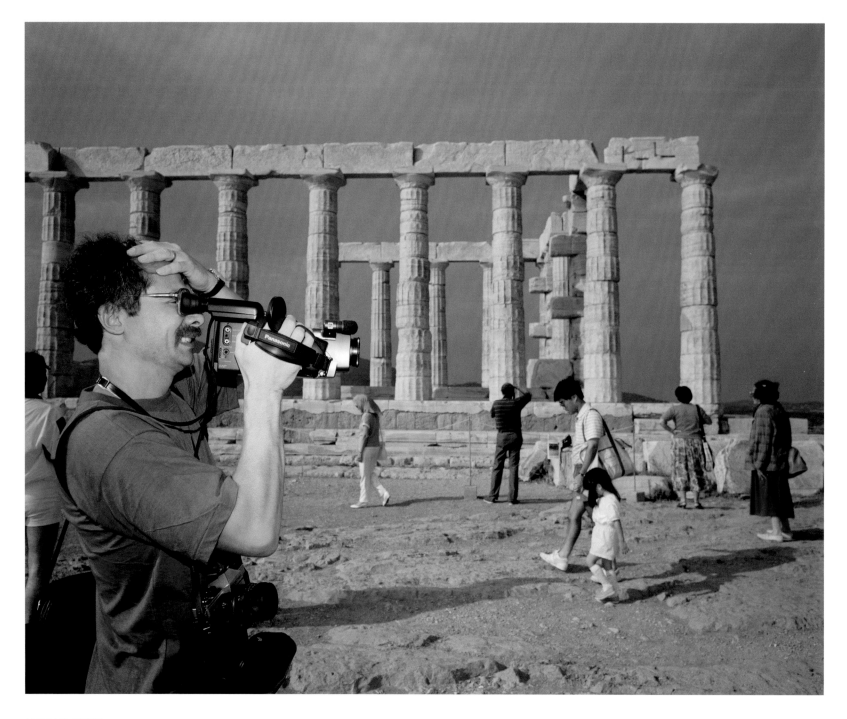

SOUNION, GREECE

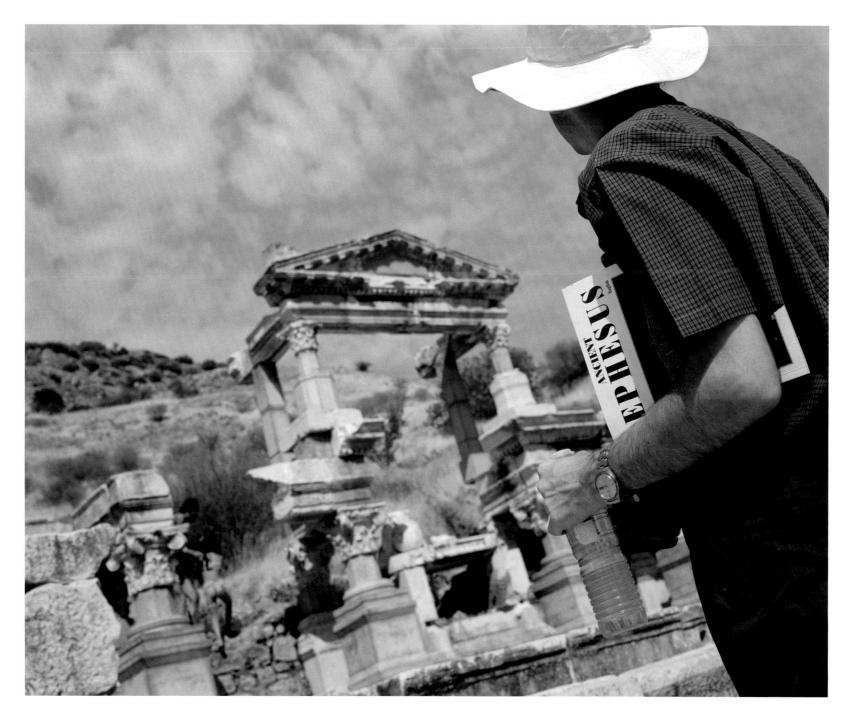

EPHESUS, TURKEY

GRAND CANYON, USA

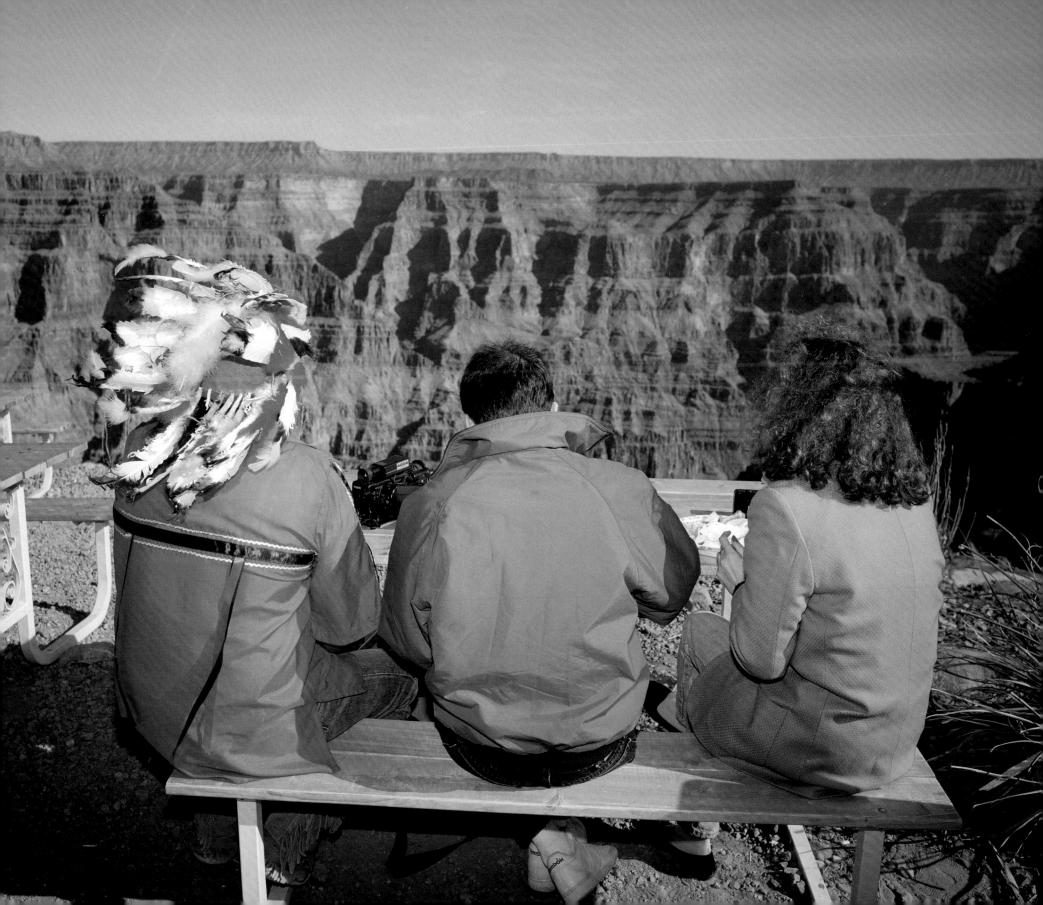

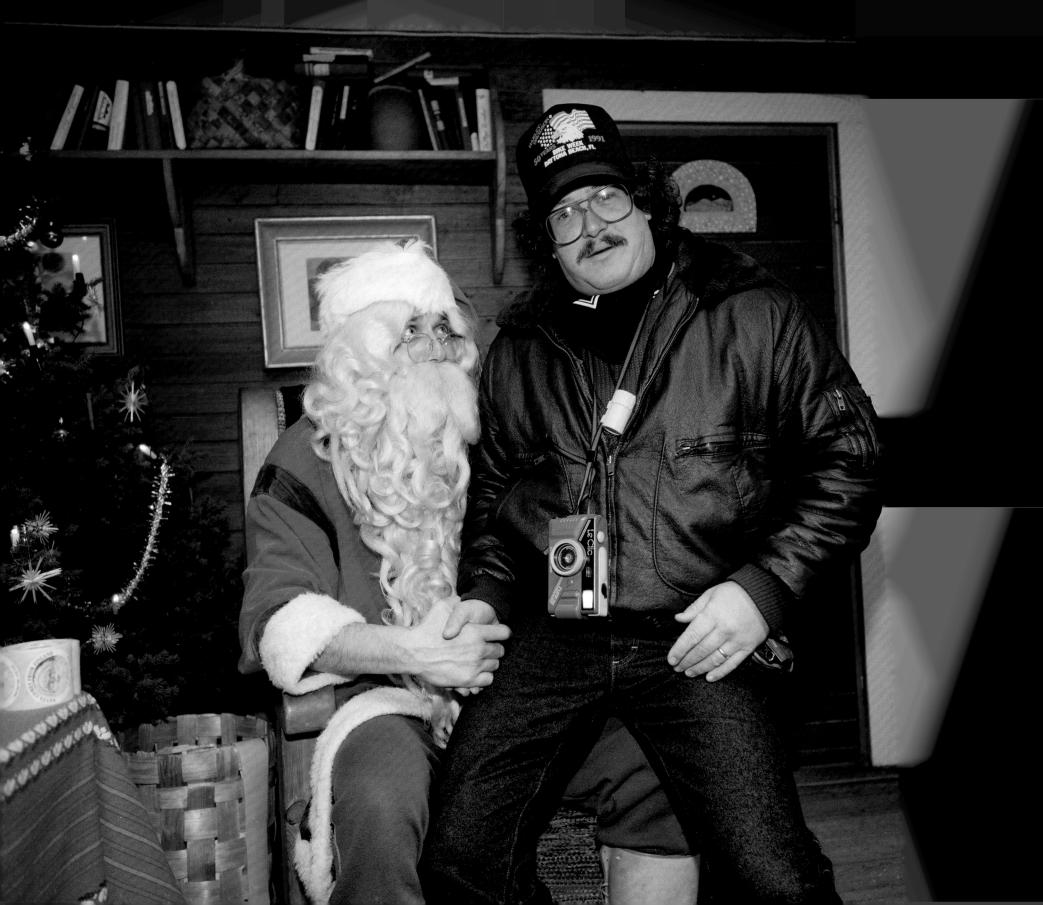

THE REAL SANTA CLAUS, ARCTIC CIRCLE SHOPPING CENTRE, LAPLAND

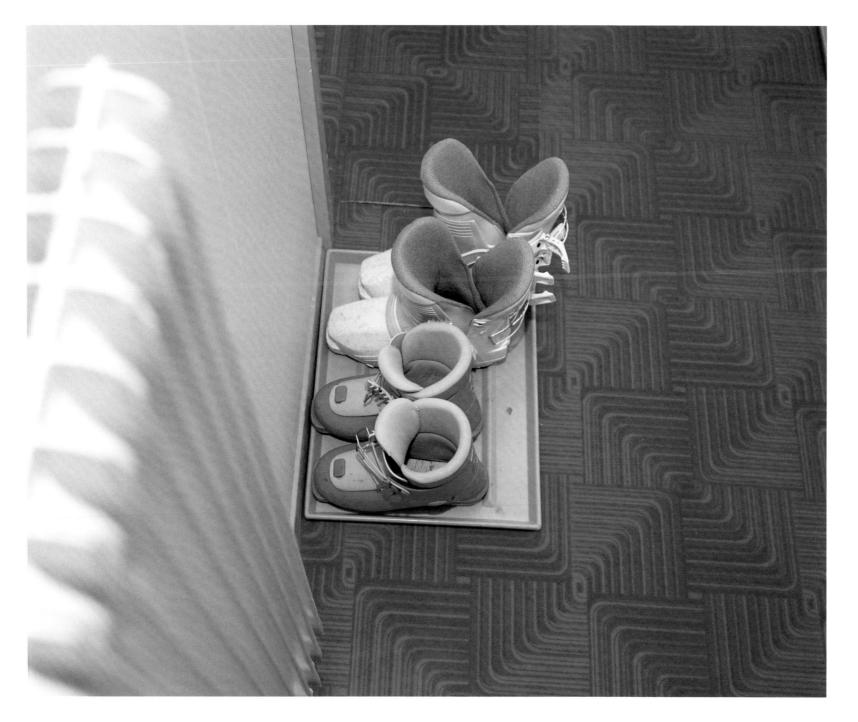

WENGEN, SWITZERLAND

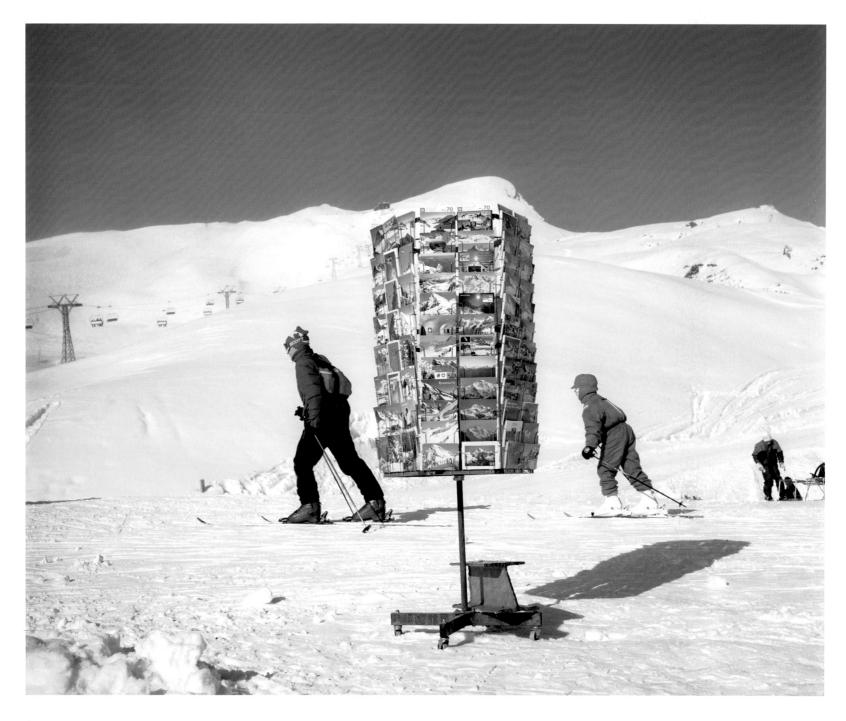

above: KLEINE SCHEIDEGG, SWITZERLAND
right: THE MATTERHORN, SWITZERLAND

64

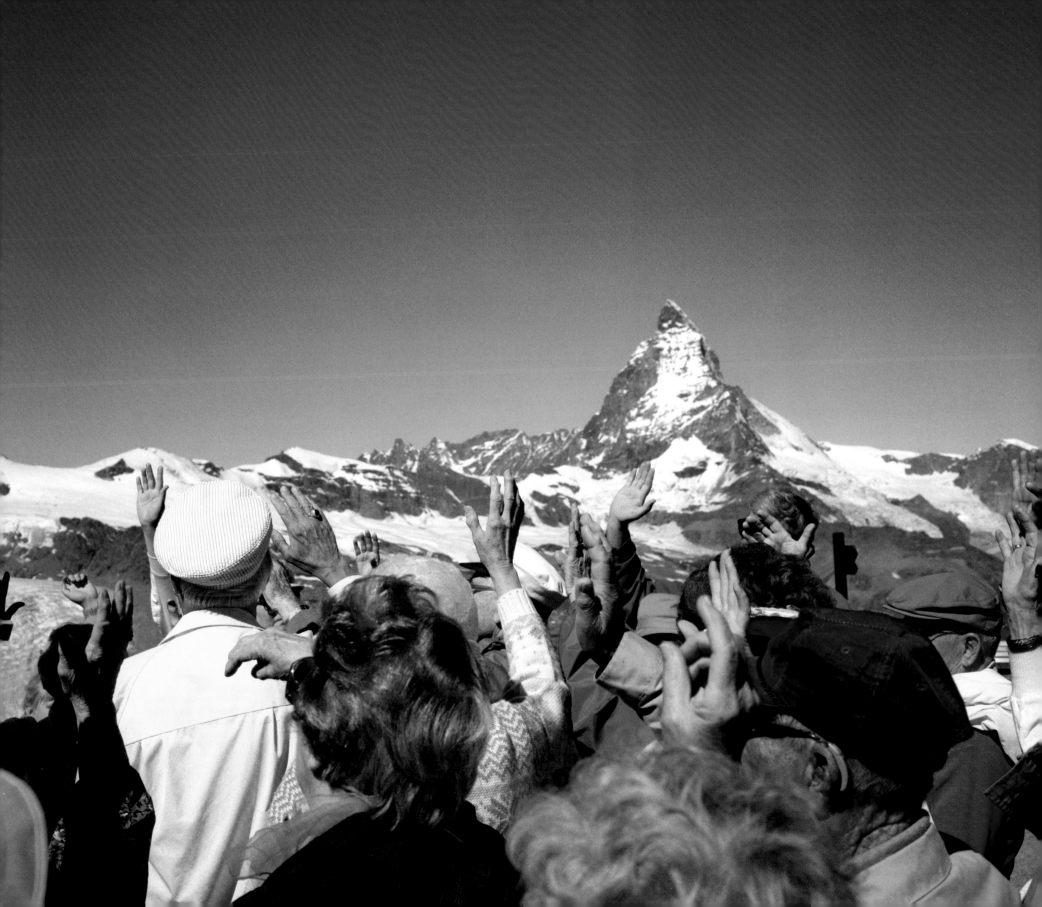

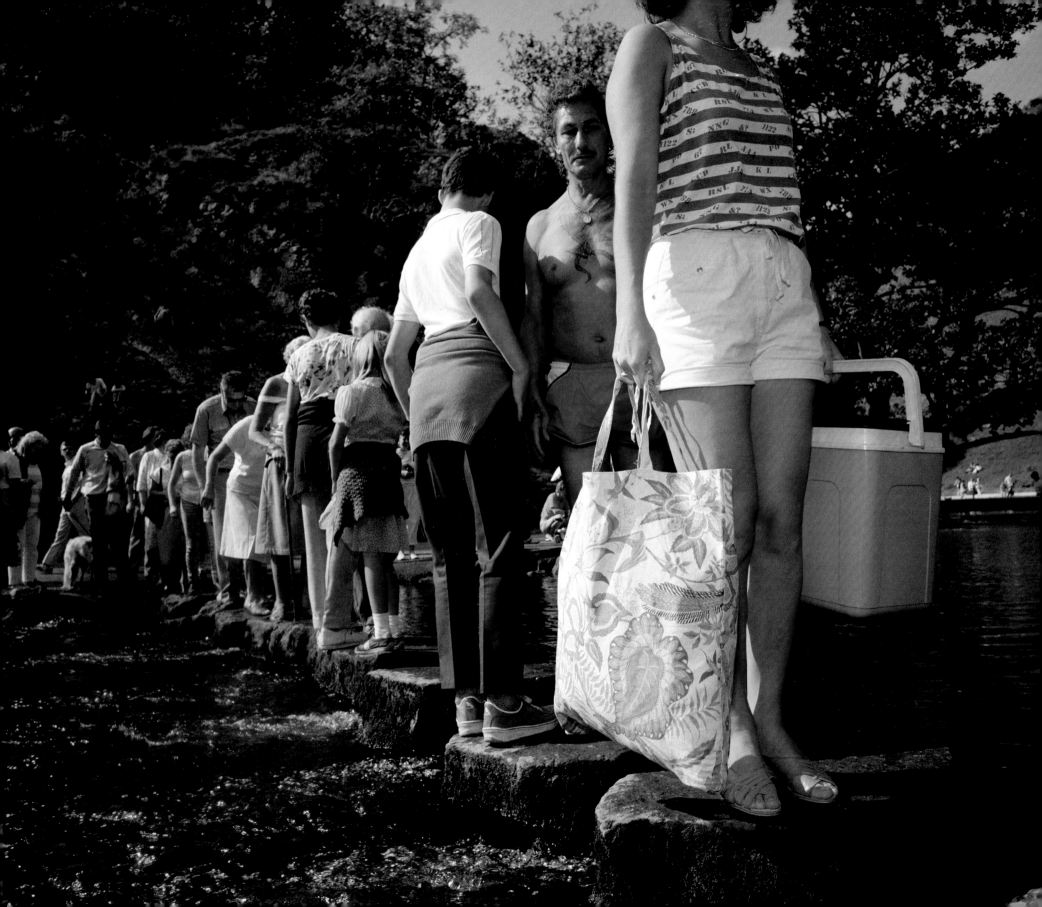

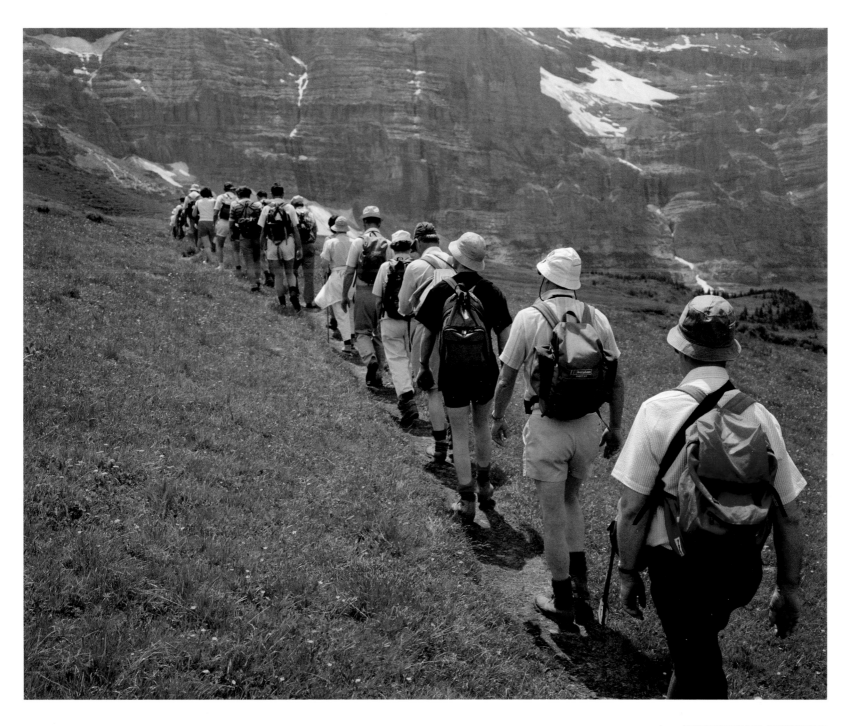

above: KLEINE SCHEIDEGG, SWITZERLAND
left: PEAK DISTRICT, ENGLAND

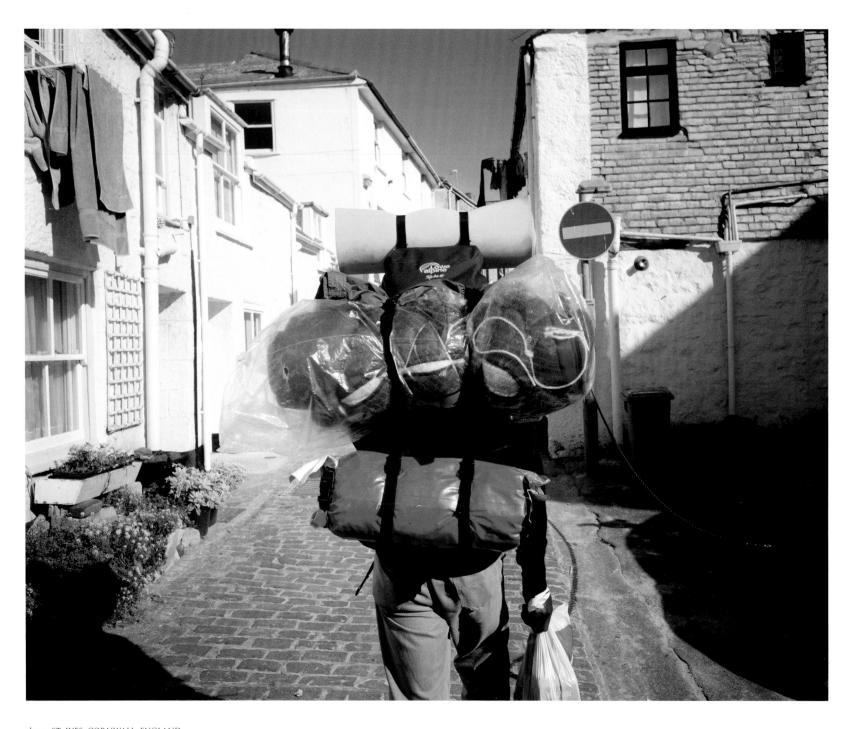

above: ST. IVES, CORNWALL, ENGLAND
right: KEUKENHOFF, HOLLAND

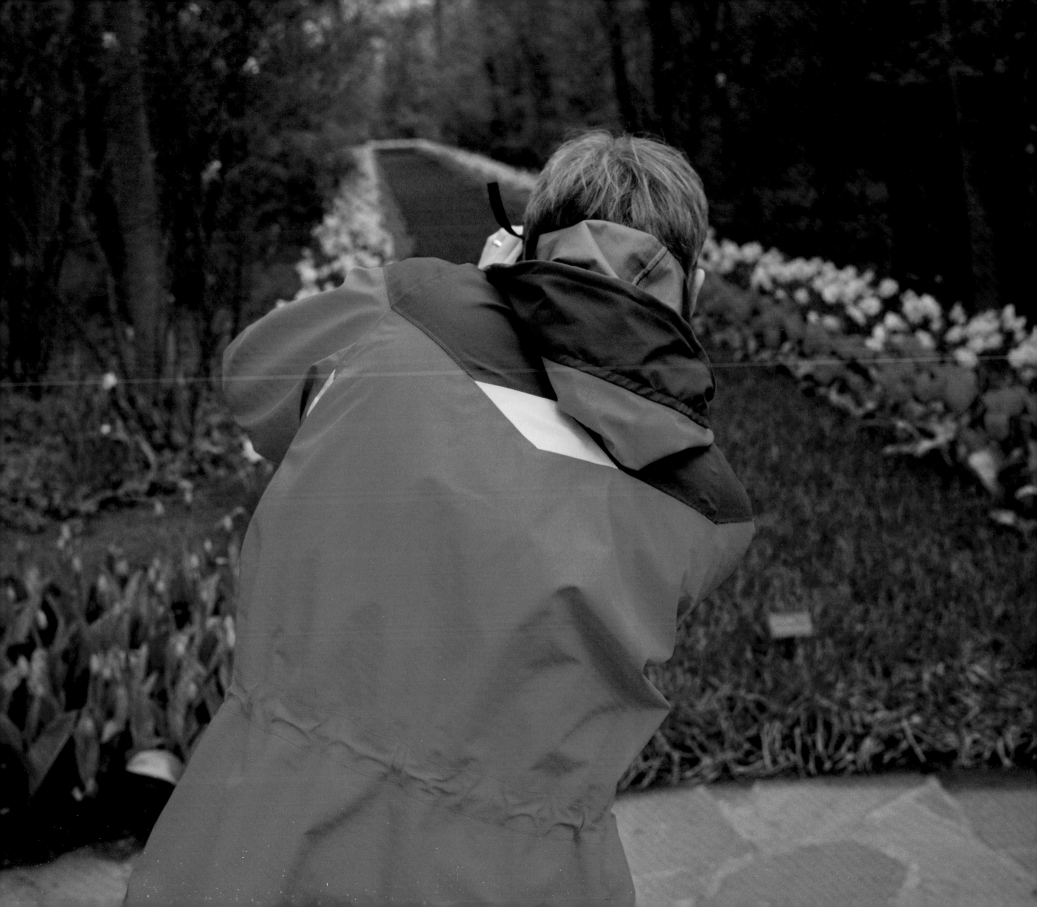

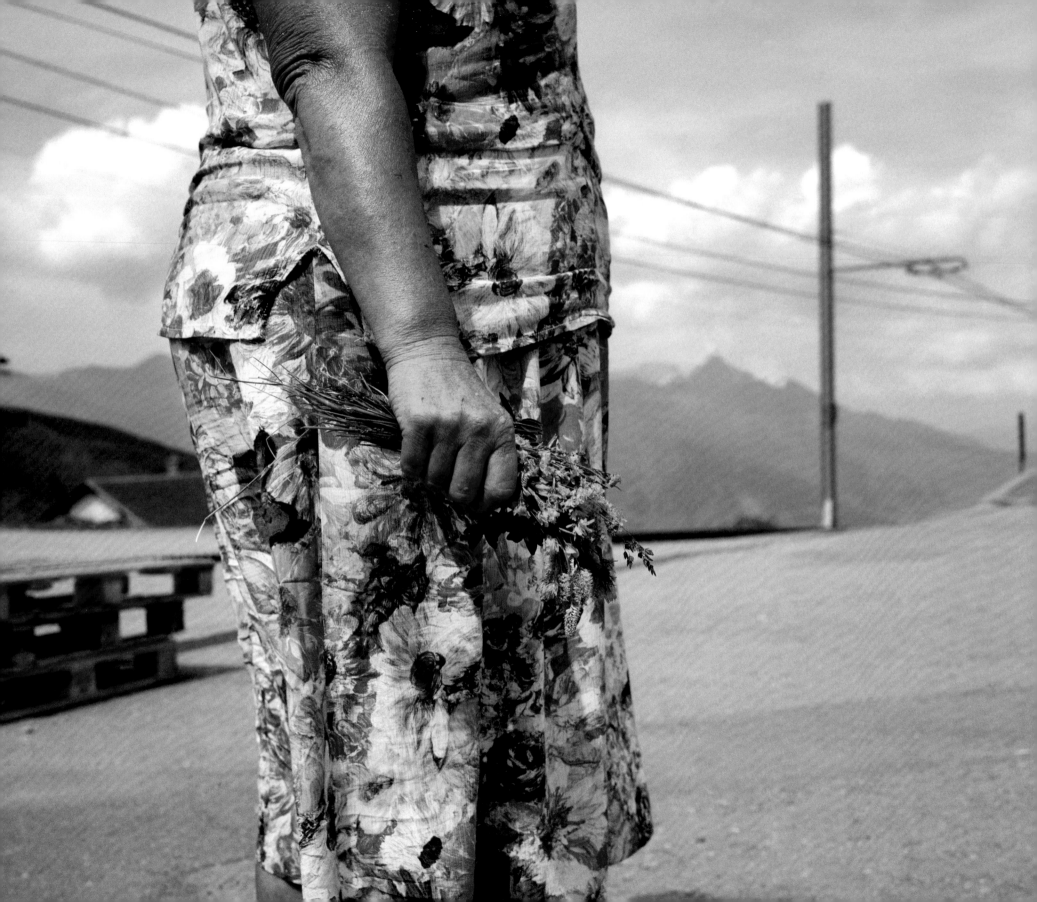

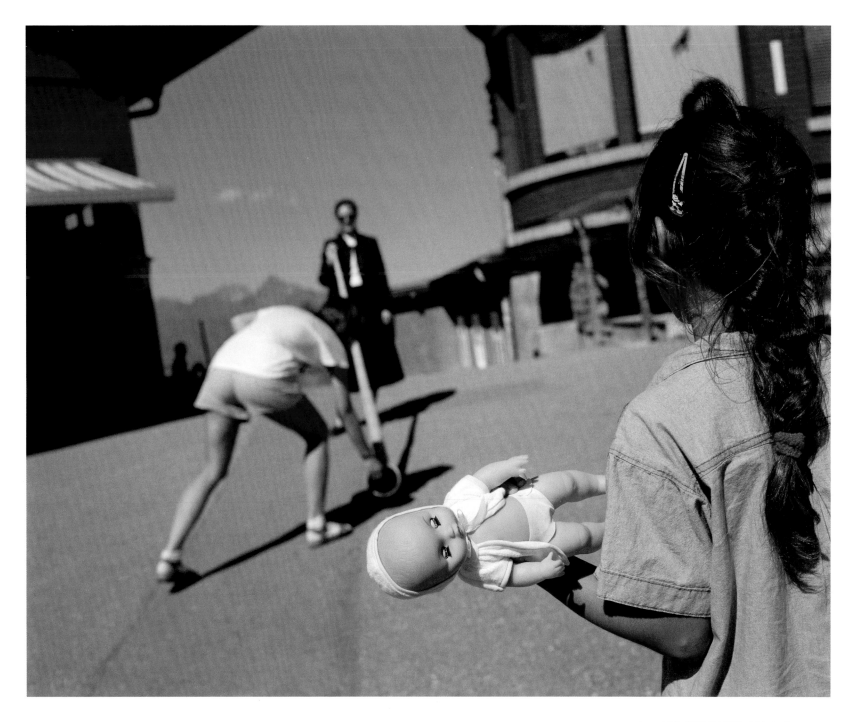

above & left: KLEINE SCHEIDEGG, SWITZERLAND

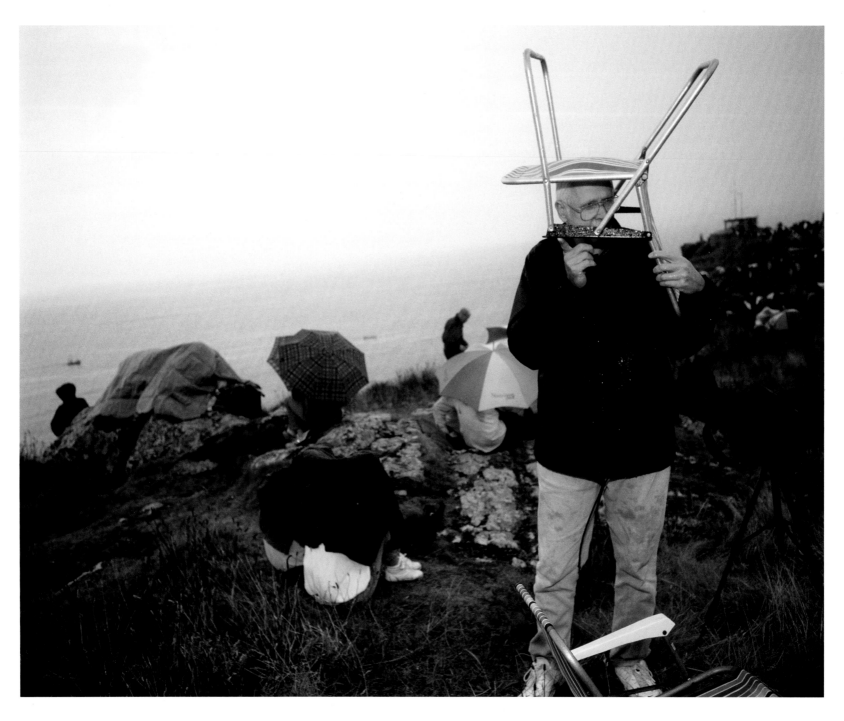

above & right: ST. IVES, CORNWALL, ENGLAND

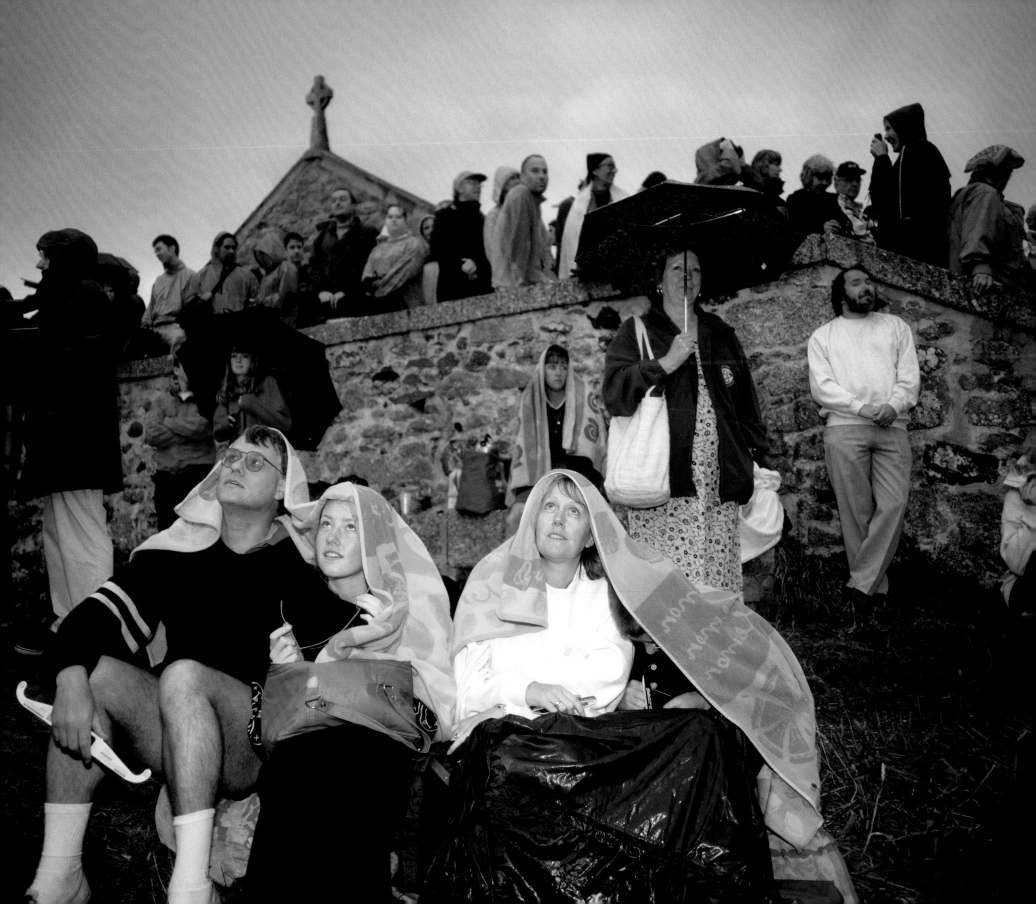

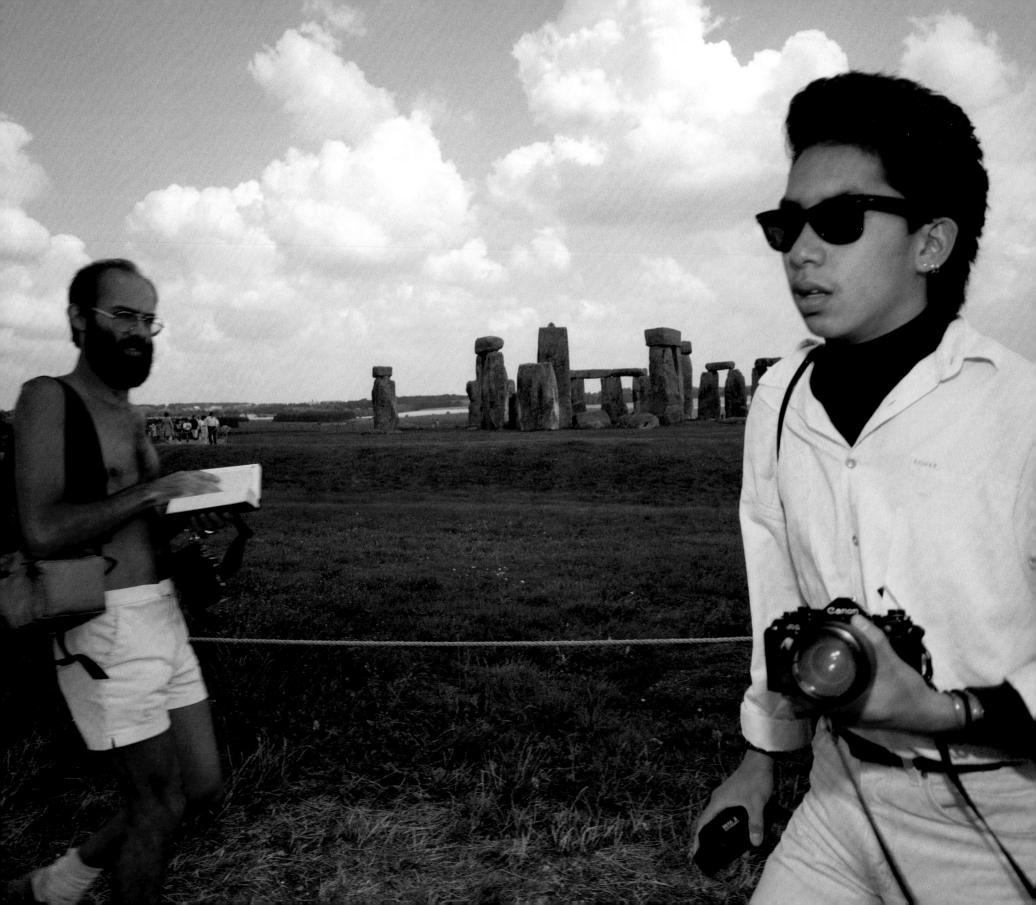

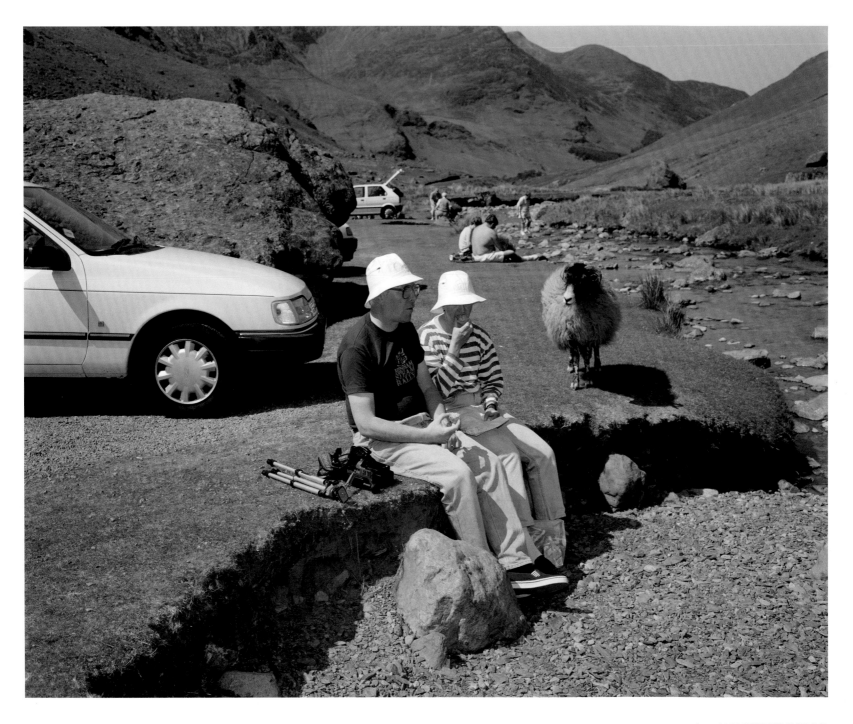

above: LAKE DISTRICT, ENGLAND
left: STONEHENGE, WILTSHIRE, ENGLAND

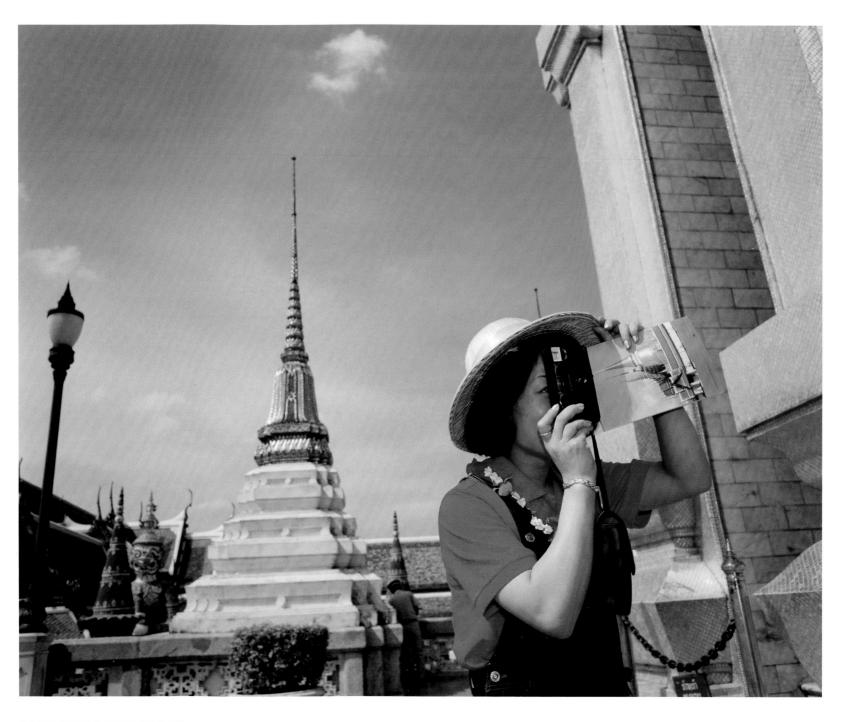

GOLDEN TEMPLE, BANGKOK, THAILAND

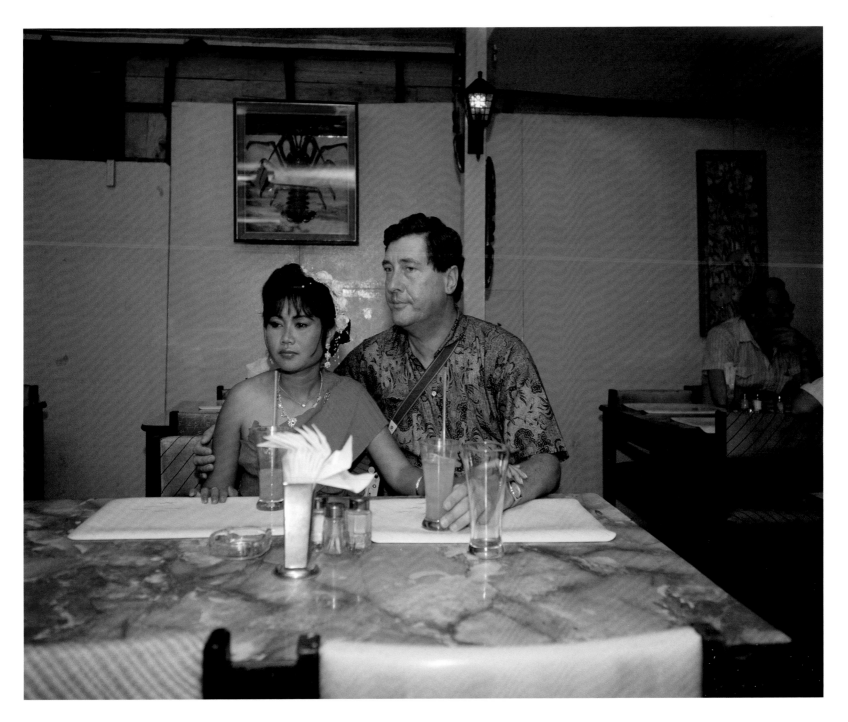

PATTAYA, THAILAND

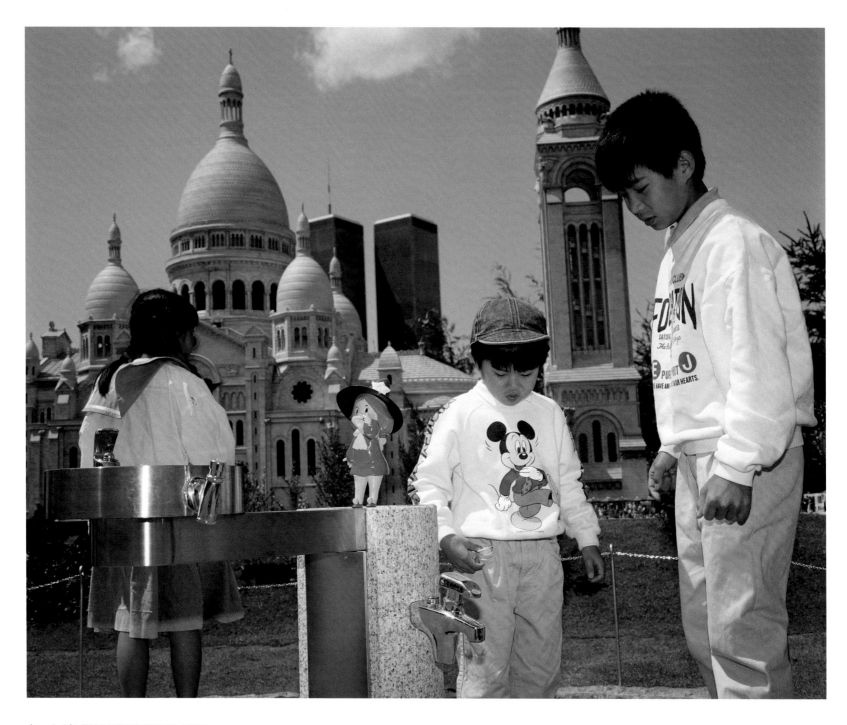

above & right: TOBU WORLD SQUARE, JAPAN

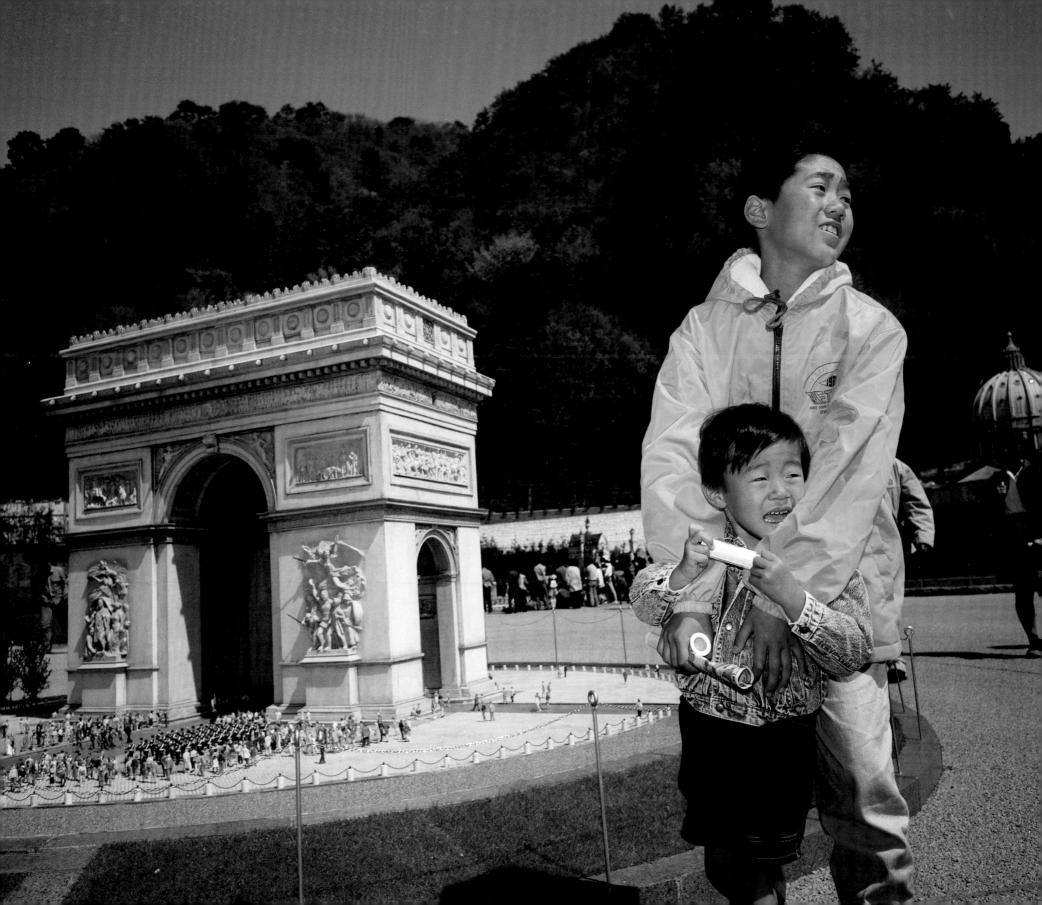

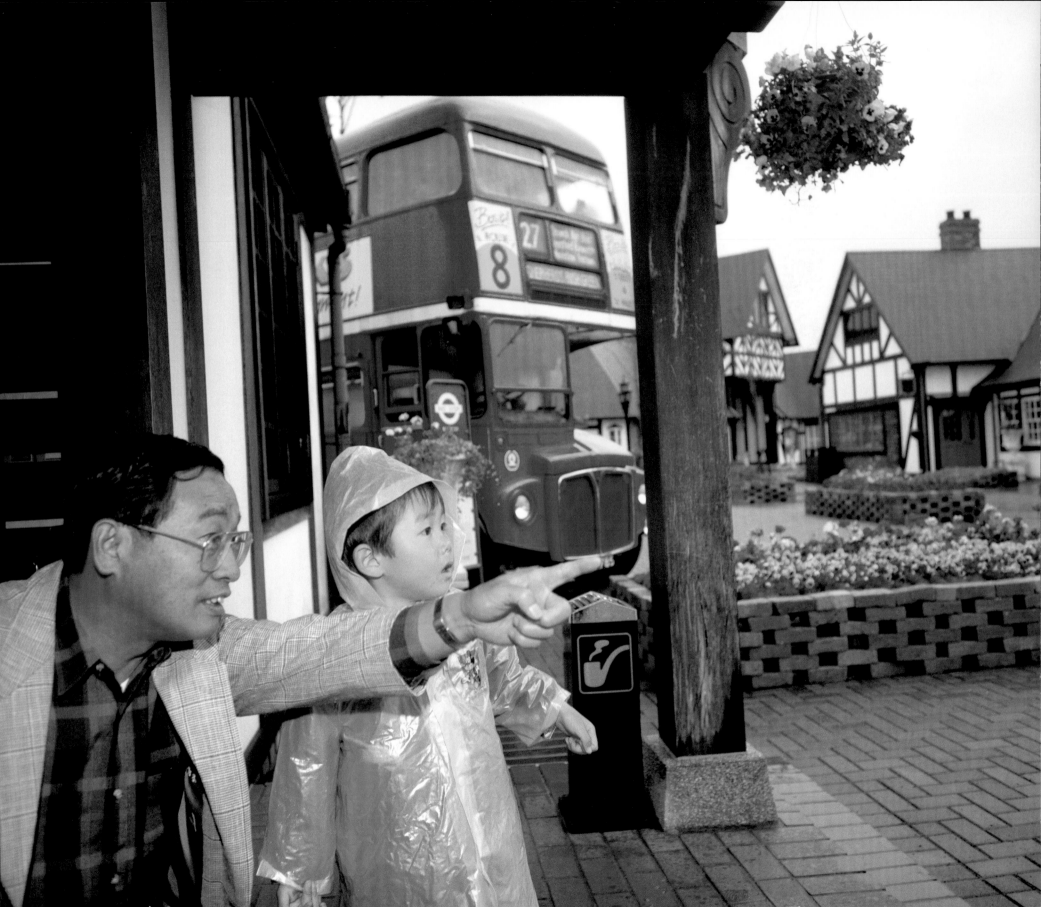

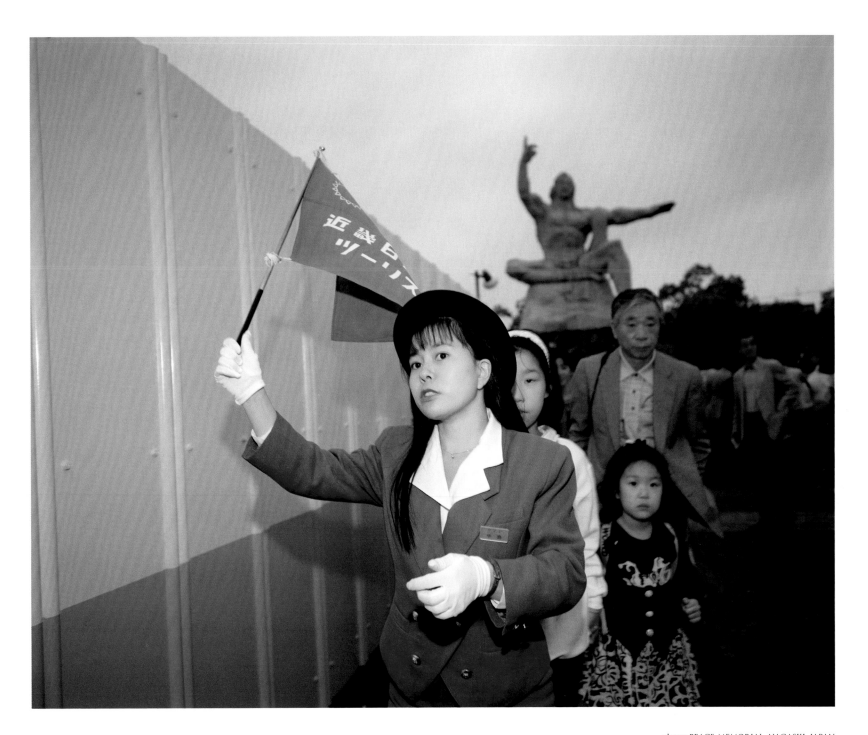

above: PEACE MEMORIAL, NAGASKI, JAPAN
left: RAINBOW VILLAGE BRITISH THEME PARK, JAPAN

OCEAN DOME, MIYAZAKI, JAPAN

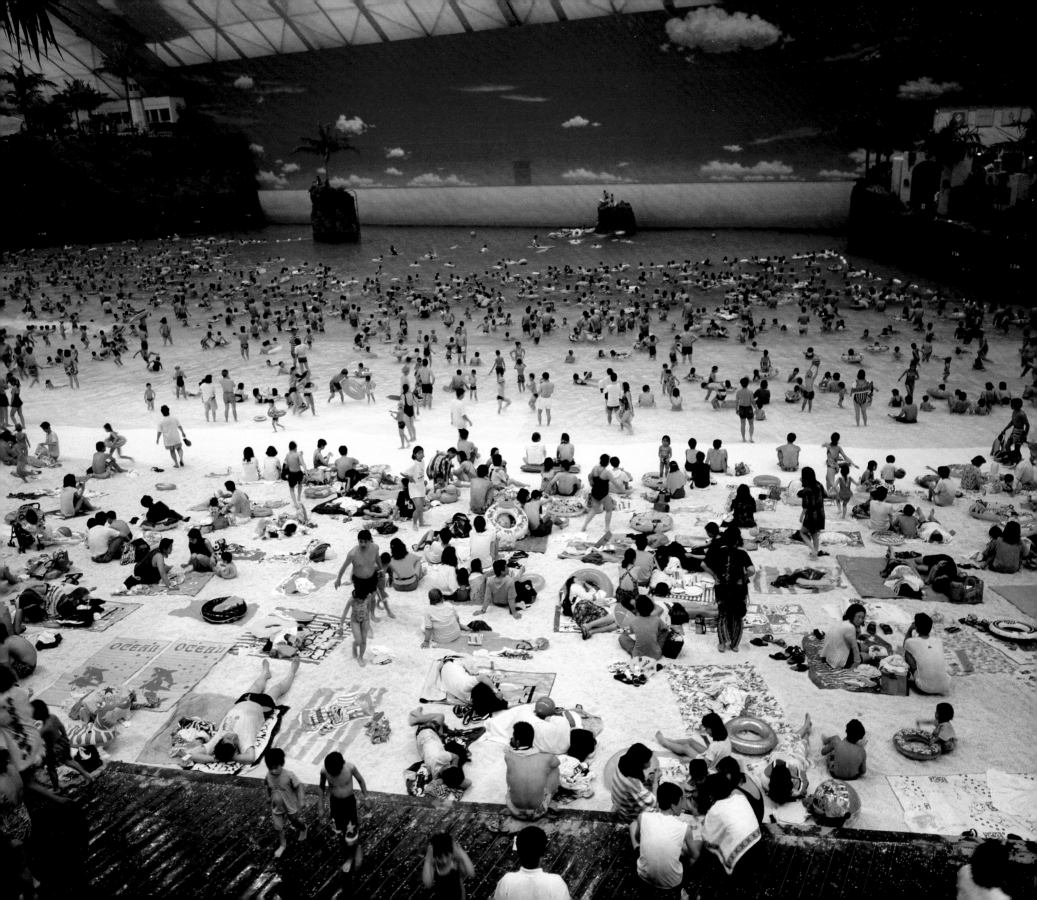

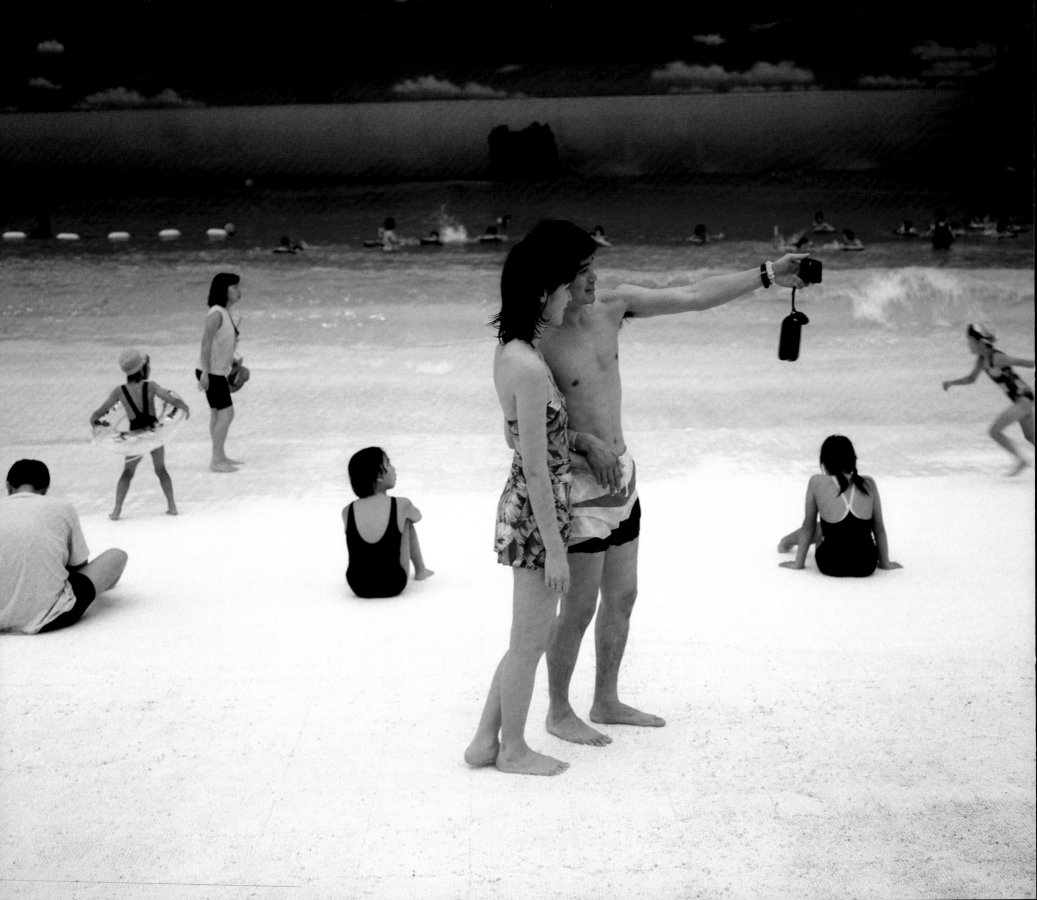

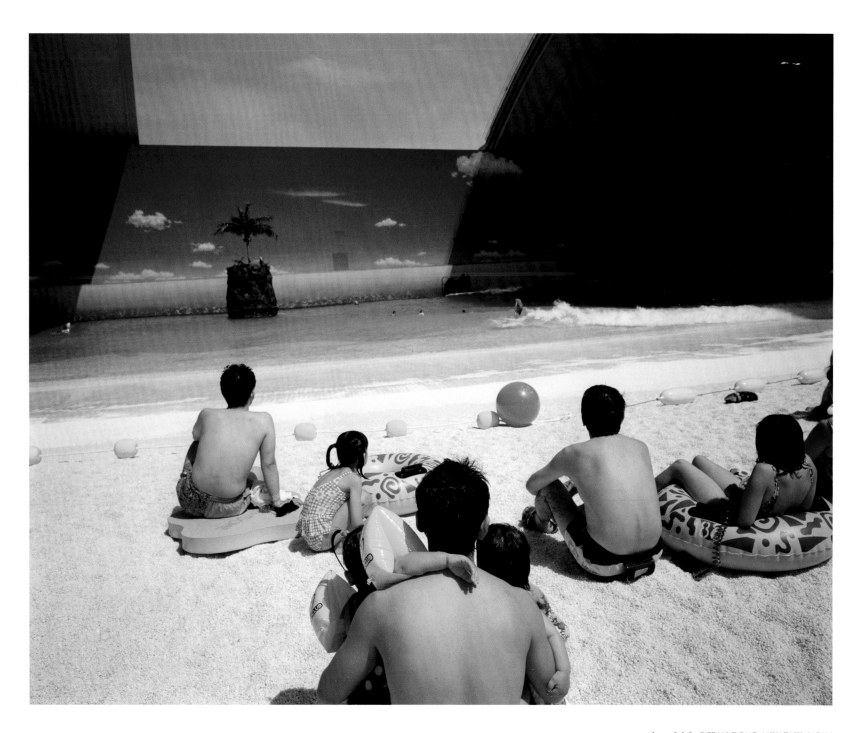

above & left: OCEAN DOME, MIYAZAKI, JAPAN

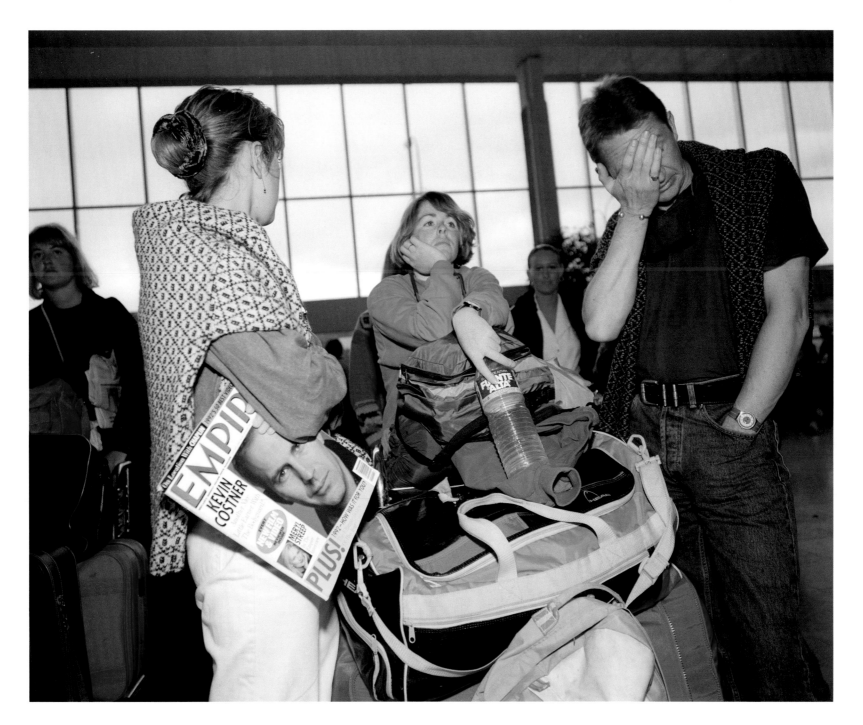

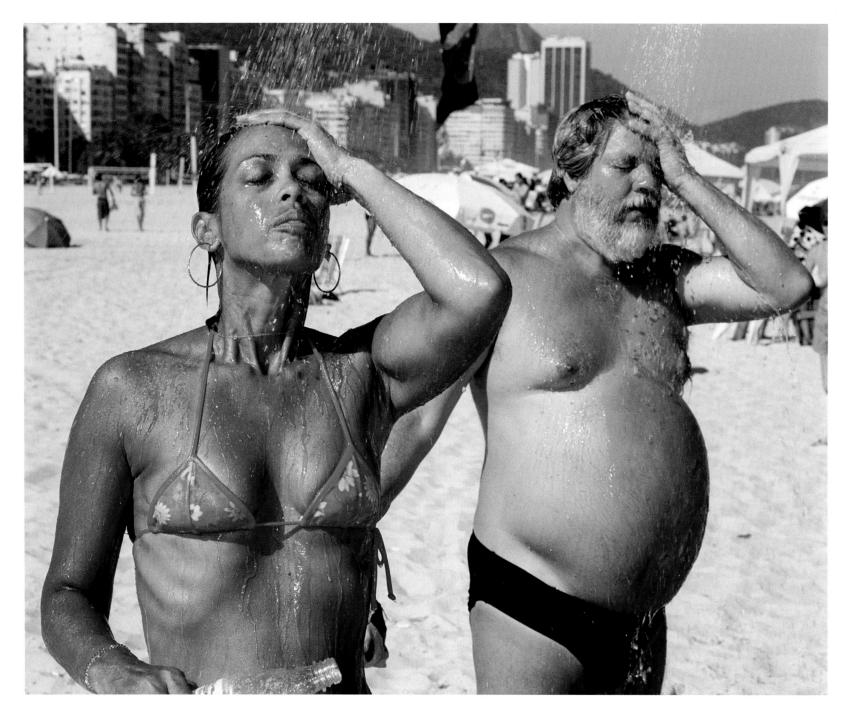

COPACABANA BEACH, RIO DE JANIERO, BRAZIL

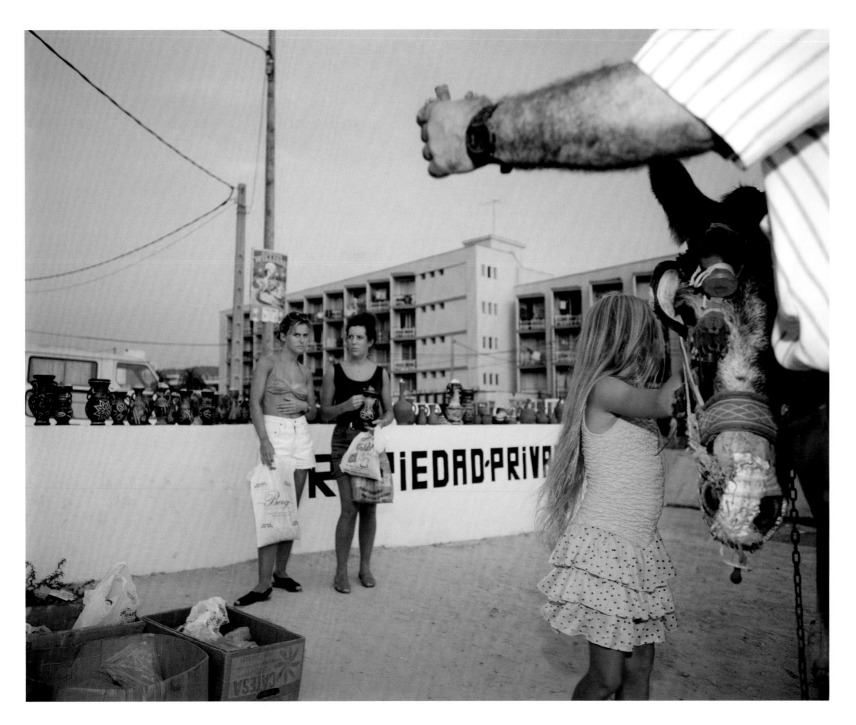

SANTA PONSA, MAJORCA, SPAIN

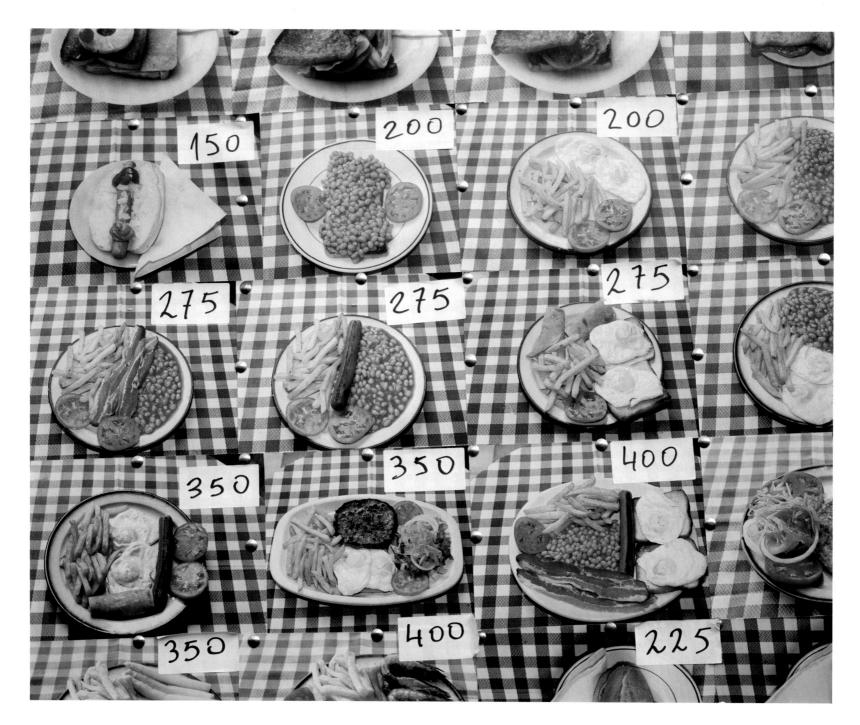

above & right: PLAYA DE LAS AMERICAS, TENERIFE

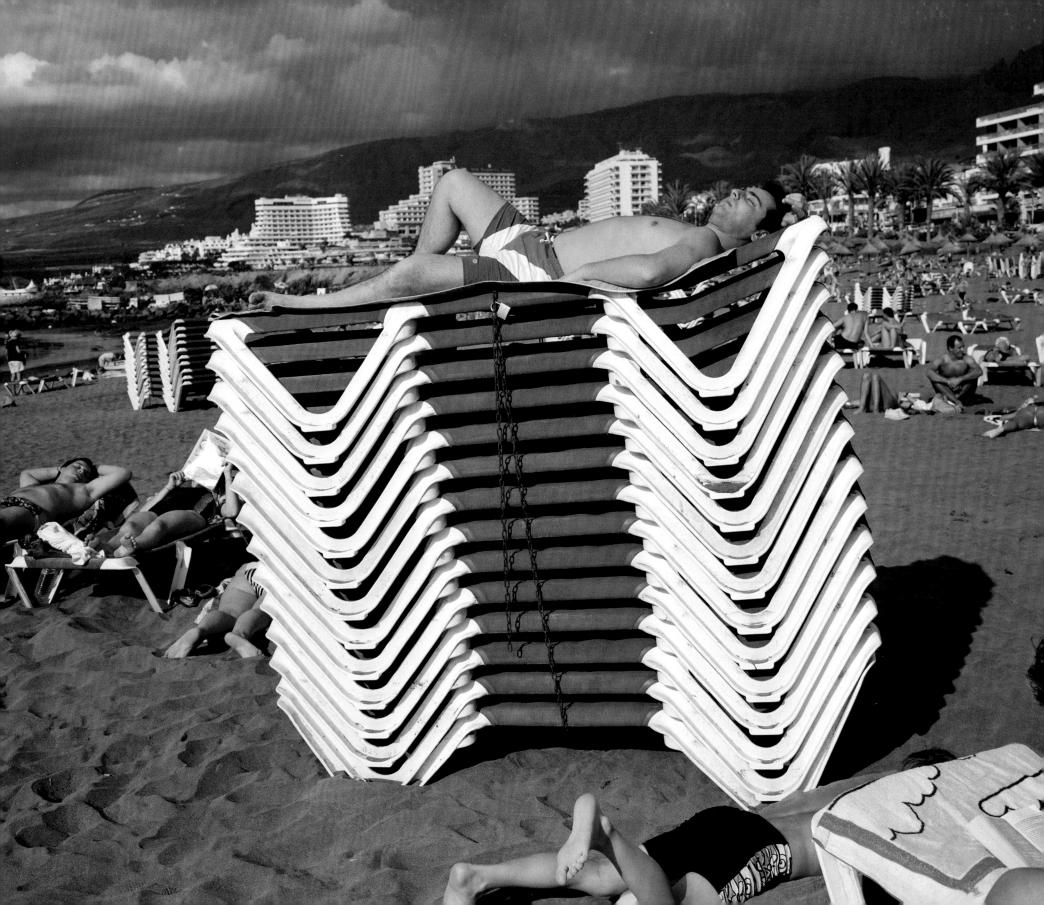

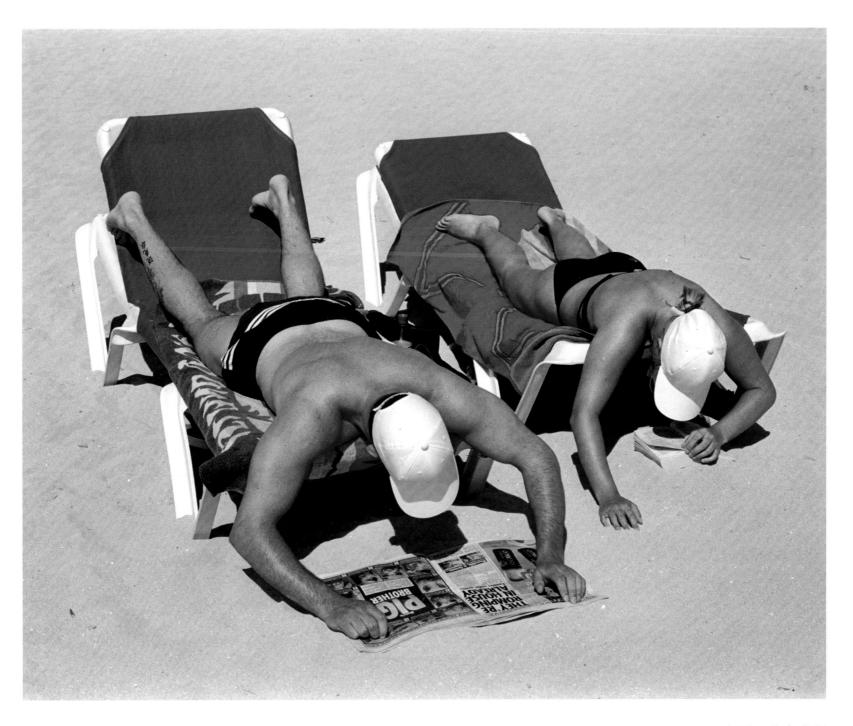

MAGALUF, MAJORCA, SPAIN

BETWEEN LONDON AND KINGSTON, JAMAICA

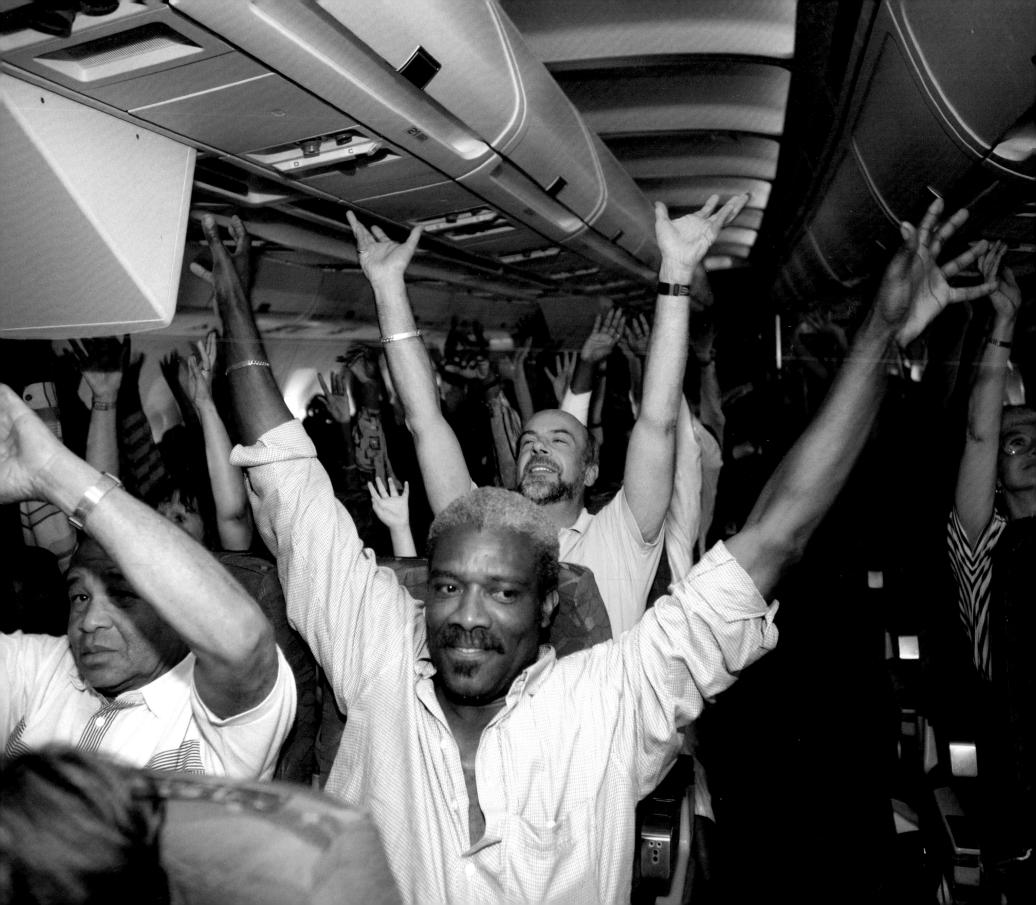

SMALL WORLD was first published by Dewi Lewis Publishing in 1995
This revised edition was published in the United Kingdom in 2007

Dewi Lewis Publishing
8, Broomfield Road
Heaton Moor
Stockport SK4 4ND
England

www.dewilewispublishing.com

For the photographs: © 2007 Martin Parr/MAGNUM PHOTOS
For the texts: © 2007 Geoff Dyer
For this edition: © 2007 Dewi Lewis Publishing

The right of Martin Parr to be identified as Author
of this work has been asserted by him in accordance
with the Copyright, Designs and Patents Act 1988

ISBN: 978-1-904587-40-8

Edited by Dewi Lewis
Design & artwork production: Dewi Lewis Publishing
Print: EBS, Verona, Italy

Reprinted March 2008